HAMPSTEAD HEATH

FROM THE
Thomas Barratt Collection

HAMPSTEAD HEATH

FROM THE
Thomas Barratt Collection

Michael Hammerson

AMBERLEY

Acknowledgements

The Curators of the Unilever Archives, for permission to make extensive use of their biographical note on Thomas Barratt in my biographical chapter, for which I also drew on the detailed Wikipedia entry on Thomas J. Barratt; The Highgate Literary and Scientific Institution for allowing me to study their copy of Barratt's *Annals of Hampstead*; Nigel Winder, who runs the very informative unofficial Hampstead Heath website (http://www.hampsteadheath.net/index.html), for long discussion and exchange of ideas which eventually enabled me to identify Barratt's views Nos 2 and 24; The owner of Northstead, North End Avenue, for patiently tolerating my unannounced arrival on their doorstep and providing information which helped confirm the identification of views Nos 2 and 24; All maps are reproduced, at various sizes, from the 1958 Ordnance Survey map, scale 6 inches to 1 mile.

First published 2014

Amberley Publishing
The Hill, Stroud
Gloucestershire, GL5 4EP

www.amberley-books.com

British Library Cataloguing in Publication Data.
A catalogue record for this book is available from the British Library.

ISBN 978 1 4456 3295 7 (print)
ISBN 978 1 4456 3304 6 (ebook)

Typesetting and Origination by Amberley Publishing.
Printed in the UK.

Contents

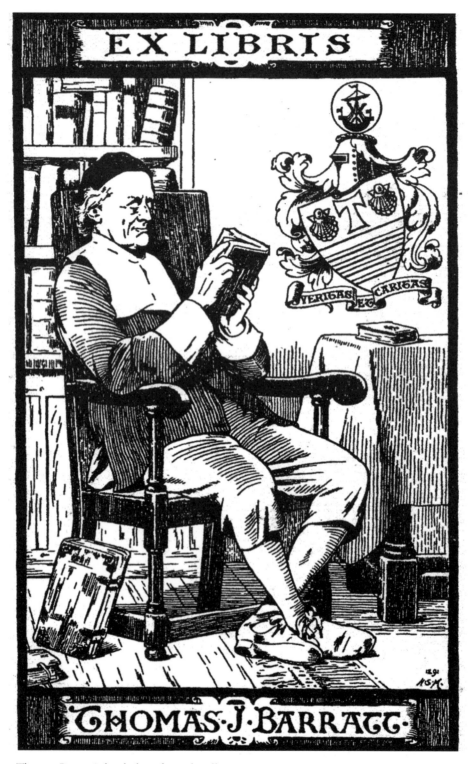

Thomas Barratt's bookplate, from the album.

Introduction

In 1983, as a new and unsuspecting member of the Highgate Society, I was persuaded to take up the chairmanship of its Environment Committee by the late Lady Susan Cox, a founder of the society and a leading reason for its formidable reputation in local town planning issues. Learning that I had an interest in local history, Susan one day handed me an album of photographs that she had been given some twenty years before by a resident of a local home for elderly people, and which she generously thought I might like. It contained sixty-two early photographs of the Hampstead Heath area, and, to my surprise, bore the bookplate of Thomas J. Barratt, the great late-nineteenth-century to early-twentieth-century historian of Hampstead.

For the following thirty-odd years, the album lay on my shelves, research on it constantly deferred by the demands of work, life and, by no means least, the unrelenting – if immensely rewarding – planning workload of the Highgate Society and its highly professional planning committee. It was not until 2013, when Amberley Publishing published my *Highgate from Old Photographs*, that I hesitantly asked whether they thought a book presenting Barratt's 1880s photographs of Hampstead and the Heath to the public would be of interest. They did.

It has been a great pleasure, as well as a learning experience, to work on the album and bring its contents to light for the first time since it was put together over 120 years ago. It obliged me to take a renewed look at the topography of the Heath in order to identify a number of the views. Interestingly, none of the sixty-two photographs were used by Barratt in his seminal work *The Annals of Hampstead*, and none have been published elsewhere except for six random views used anonymously in Baines' 1890 *Records of the Parish, Manor and Borough of Hampstead*, making them an important new visual source for Hampstead and the Heath during the 1880s.

This does not set out in any way to be a history of Hampstead or the Heath, a task for which I am quite unfitted. For the historical background, a wide range of works is available, a selection of which are cited in the bibliography.

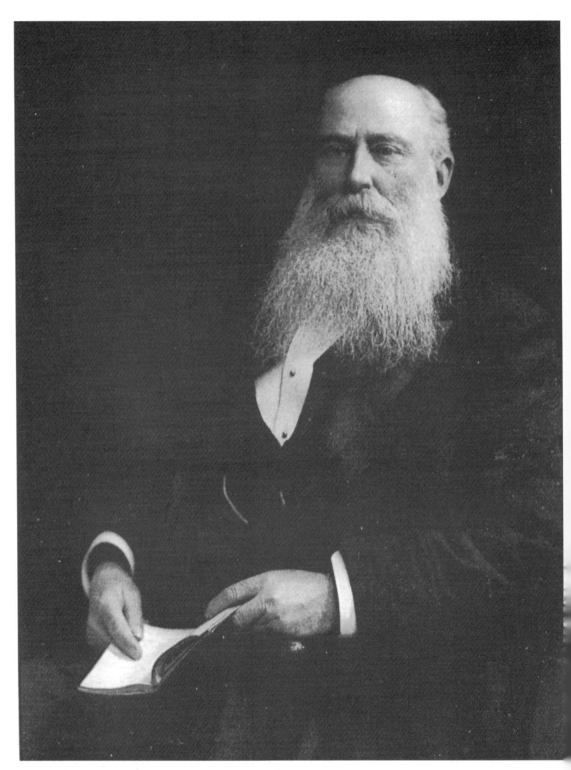

Thomas Barratt from his *Annals of Hampstead*.

Thomas J. Barratt
A Biographical Note

Thomas James Barratt, 'the man who washed the face of the world', was born at No. 25 Tottenham Place, St Pancras, London, on 16 May 1841. The son of Thomas, a piano maker, and his wife Emma, he was educated at a private school in North London, leaving at fifteen to be apprenticed with merchants George and Frederick Evans of Mincing Lane, London. A hard worker with a natural entrepreneurial flair, he moved on to London colonial brokers Ellis & Hales and in 1863 joined A. & F. Pears as a bookkeeper in their shop at Great Russell Street.

Andrew Pears had come to London from his native Cornwall, and in his Soho barber's and wigmaker's shop he made rouges, creams and powders for the face, at a time when such products often contained dangerous ingredients such as arsenic or lead. In 1789 he invented his distinctive transparent soap, a product based on glycerine and natural oils that avoided all impure substances and was scented with herbs and flowers. The soap was sold in square blocks at 1s a block, or large perfumed blocks at 2s 6d. It was still a small family firm when Barratt joined in 1863 as a travelling salesman; by 1865 he was already a partner with Francis Pears, the founder's grandson, and Andrew Pears, Francis's son, and in the same year he married Mary, Francis's eldest daughter. Leaving the soap works to be run by his partners, he dedicated himself to expanding the firm through advertising, a practice in some disrepute at the time through its association with failures and fraud. Francis was unhappy with Barratt's new approach and retired in 1875, leaving £4,000 in capital. Barratt focussed on advertising, while Andrew Pears managed the works at Isleworth, Middlesex.

Barratt became a pioneer in the world of advertising, Lord Northcliffe calling him the 'father of modern advertising, from whom I have learnt so much'. He transformed the company with campaigns that became well known, and Pears became one of the world's most heavily promoted brands. When Barratt joined the company, advertising expenditure had been about £80 a year; by the time he died, it was about £100,000. He had an original approach to advertising; he was keen to equate Pears with quality and high culture, and acquired works of art to use in his advertisements.

By presenting the name Pears in different patterns and formats, he got round newspaper restrictions against illustrated advertisements. Regular daily advertising made the Pears name familiar worldwide; Barratt claimed that the average reader would see the name 2,000 times. Gladstone, speaking in the House of Commons, referred to amendments 'as thick as the leaves in Vallombrosa, or as plentiful as the advertisements of Pears soap'.

Barratt also used testimonials from well-known figures, including actress Lillie Langtry, singer Adelina Patti, and the president of the Royal College of Surgeons, Dr Erasmus Wilson – all, of course, well paid for their support. Barratt even bought the whole front page of *The New York Times*, and put on it a testimonial from noted American divine Dr Henry Ward Beecher, well known from his lecture tours of England and brother of Harriet Beecher Stowe, author of *Uncle Tom's Cabin*. He sent soap and advertising leaflets to babies whose birth was noted in *The Times*. Catchphrases such as 'Good morning, have you used Pears soap?' and 'How do you spell soap? Why, P-E-A-R-S, of course', became familiar, and the words 'soap' and 'Pears' became synonymous in the public mind. 'Any fool can make soap', Barratt said, 'It takes a clever man to sell it.' When asked if anyone really read his advertisements, his reply, 'It is wrong to say that no one reads them; they are not there to be read, but to be absorbed', showed an understanding of the psychology of advertising far ahead of its time.

With William Lever, Lord Leverhulme (who had made his fortune in the chemical industry, founded the model industrial complex at Port Sunlight, Cheshire, and was a close neighbour of Barratt's at The Hill, North End Way – the two remained friendly rivals), Barratt was an innovator of the use of art in advertising. The most famous work of art used for Pears advertising was *Bubbles* by Sir John Millais, which generated great debate at the time about the use of art in this way. Barratt bought the painting, originally called *A Child's World*, from the *The Illustrated London News* in 1886 and used it in his advertising campaigns, adding a bar of soap to the foreground of the painting. Millais was originally unhappy about the painting of his grandson being used for advertising, but was reassured when he saw the care taken to reproduce the work. The painting inspired a whole genre of advertisements using endearing-looking children in middle-class homes. Like Lever, Barratt was a collector of art. Through his 'Pictures for People' plan, he bought works of art and sold high-quality reproductions at a nominal price, bringing the Pears name into millions of homes. Barratt also introduced the *Pears Annual* (1891–1925), which reproduced colour paintings by well-known artists and contained stories commissioned from eminent writers, and the *Pears Cyclopaedia*, launched in 1897 and still published. Produced annually since 1953, it was until then published frequently but erratically, with three editions in some years and none in others. It features an atlas, a gazetteer, a list of prominent people past and present, a miniature encyclopaedia of general information, and a chronological list of events, with other sections on specialist subjects varying from year to year.

Barratt took every opportunity for advertising; he even offered the government £100,000 to carry Pears advertising on census forms, but they declined. Around 1889, he persuaded the Post Office to get De La Rue, the company which printed the British postage stamps, to experiment with printing 'PEARS' SOAP' on the back of stamps.

A trial printing was made on the backs of the 1881 1d lilac and the 1887 Jubilee ½d vermilion stamps, but difficulties were encountered and the project got no further. In 1885 he imported 250,000 ten-centime coins from France; these were legal tender at the time in the UK, but there was no law banning the defacement of foreign coins, so he stamped them with the Pears name before putting them into general circulation, obliging the government to legislate to stop the circulation of foreign coinage in the UK. He even linked Pears to British Imperial culture, associating its cleansing power with worldwide commerce and the empire's supposed civilising mission; one advertisement proclaimed, 'The first step towards lightening the White Man's Burden is through teaching the virtues of cleanliness. PEARS' SOAP is a potent factor in lightening the dark corners of the earth.'

Barratt's methods led, inevitably, to their being parodied, the most famous being a Harry Furniss cartoon in *Punch*, parodying Lillie Langtry's testimonial and showing a tramp writing a letter to Pears, saying, 'I used your soap two years ago, and have not used any other since.' Barratt *was* amused, and bought the rights to use the cartoon in his own marketing. He was also well aware of the need to change, stating in 1907 that 'tastes change, fashions change, and the advertiser has to change with them. An idea that was effective a generation ago would fall flat if presented to the public today. Not that the idea of today is always better than the older idea, but it is different – it hits the present taste.'

Pears soap became one of the best-known products of the era. In 1892, A. & F. Pears became a public company, with £810,000 in assets and paying a 10 per cent dividend; the shares were eagerly bought up. In 1913, shareholders organised a banquet at the Savoy and commissioned a portrait of Barratt by Solomon J. Solomon RA to commemorate the fiftieth anniversary of his joining the firm.

Barratt had many other interests, to which he brought the same enthusiasm and drive. An early conservationist, he was dedicated to the battle to save Hampstead Heath. While the core of the Heath lands had already been saved by 1871, and the Parliament Hill Fields and East Park were added in 1889, the land and mansion of Golders Hill came under threat following the death of the owner, Sir Thomas Spencer Wells, in 1897. It was put up for auction in 1899 at a time when development for what would today be termed 'luxury housing' in the expanding London suburbs was starting to swallow up much of the area. When the bidding for Golders Hill went above the sum collected by local campaigners, Barratt continued the bidding on his own and secured the house and park, which were then donated to London County Council (LCC).

He was also a talented local historian and antiquarian, publishing his three-volume *Annals of Hampstead* in 1912. He filled his Hampstead home, Bellmoor, with British art; his collection was notable enough to be the subject of a fifty-seven-page booklet by Joseph Grego, *The Art Collection at 'Bell-Moor', the House of Mr. Thomas J. Barratt*, published in 1898. Barratt's will specified that his collection be sold at Christie's after his death, and the 1916 auction was accompanied by a forty-four-page *Catalogue of the Important Collection of Modern Pictures & Drawings and Sculpture of Thomas James Barratt, Esq., Deceased, Late of Bell Moor, Hampstead Heath*. The house was

replaced in 1929 by a block of flats of the same names that occupies the site today, overlooking Hampstead Heath's Whitestone Pond and the Heath at the highest point in London.

Barratt was Deputy Lieutenant of the City of London, Master of the Barber's Company and a Fellow of the Royal Microscopical and Statistical Society, and was a member of several clubs. He died at the Queen's Highcliffe Hotel, Margate on 26 April 1914, and was buried on 30 April at St Pancras Cemetery, Finchley, London. At some point he had separated from his wife, and the main beneficiaries of his will were his two sons by Florence Bell, a doctor's daughter who lived with him and called herself Mrs Barratt. His collection of Nelson memorabilia was given to the Royal Naval Hospital, Greenwich. His obituary featured in *The Times* of 27 April 1914.

In the early twentieth century, Pears became part of Lever Brothers, later Unilever, and moved to Port Sunlight, Cheshire. Pears' transparent soap still remains a favourite brand to the present day, and when Lever Brothers tried to alter its perfume, a public outcry obliged them to change it back.

The Album,
the Photographs
and Their Date

The Album

Barratt's album, identified by his bookplate on the inside of the front cover (*see page 6*), measures 245 x 305 mm. The covers are faced with dark green paper stippled to resemble leather, edged in gold leaf and stamped 'PHOTOS/Hampstead and Highgate', also in gold leaf. The spine is now missing.

The sixty-two photographs, all in the sepia tone typical of later nineteenth-century photographic prints, are glued, two to a page, on thirty-one thick card pages, probably cream coloured originally but now somewhat aged down to a dull cream-yellow. There is some foxing, mainly on the first and last pages. The photographs on the first twenty-two pages (Nos 1–44) are all in the same format, measuring 141 by 96 mm±, while those on the remaining pages (Nos 45–62) are in two, larger formats: the upper photographs some 153 by 106 mm± and the lower ones 198 by 152 mm±. Some of the photographs have a number of white speckles, which does not appear to be later attack by mould or foxing, but integral to the photographs and therefore some flaw in the process of producing them.

The Photographs

The sequence in which the photographs appear in the album seems entirely random; possibly they were simply inserted in the order in which they were taken or processed. What stands out about the collection is that it also appears to be entirely random in the selection of subjects. It is far from comprehensive in terms of the extent of Hampstead Heath as we know it today (*see map on page 120*). Nine are of locations in Hampstead town, and seven show views of the Heath from what would today be termed the public

realm, but was then privately owned land. Despite the title, there is only one view of Highgate village, but this was helpful in dating the album.

The majority of the photographs are of the Heath, showing locations within the original 1871 land acquisition: the West Heath, Sandy Heath, and the area between the Whitestone Pond and the Vale of Health. A further four show Millfield Lane and two of the Highgate Ponds, and two others, I have tentatively suggested, show the boundary of the Earl of Mansfield's Kenwood estate, all of which would have been taken on land added to the Heath in 1889.

However, the album also poses two intriguing questions. Firstly, why were none of the images used in his definitive *Annals of Hampstead*? Only six were published, uncredited, in Baines' 1890 *Records ... of Hampstead*, to which Barratt was a subscriber, buying sixteen copies. Secondly, why do the photographs present such a strangely selective range of subjects, and why are so many scenes and subjects that we might expect to be included notable by their absence? None of the photographs are of the Hampstead chain of ponds, except for the Viaduct Pond, even though these were within the original 1871 acquisition land. Only one other photograph is taken on land acquired for the Heath after 1889 – the view from Kite Hill over London (No. 38). We might, for example, expect one of the Tumulus (then also known as 'Boadicea's Tomb'), or of the great Saxon boundary ditch, which must have been even more visible in that more treeless era, or of Kenwood. Perhaps even Thomas Barratt had difficulty in getting access to what was still privately owned land outside the area then called Hampstead Heath, beyond being able to use the footpaths crossing it.

Nevertheless, this does not explain why there are not more identifiable views of the central area of the Heath, or of such features as Fitzroy Farm, or the famous Heath pubs – the Spaniards Inn, the Bull and Bush or Jack Straw's Castle (other than distant views of the last two) – given that there are several of Collins' and Wyldes' Farm. Also missing are such features as the famous Gibbet Elms at North End, the last of which was not lost until 1907. Finally, since the album is titled *Hampstead and Highgate*, why is there only one, somewhat marginal, photograph of Highgate? In view of the fact that so many expected views are not present, one wonders why Barratt even troubled to take the odd view (No. 7) showing the causeway of the Vale of Health Pond from below, the almost duplicate views of the Spaniards and the North End Firs, and the uninformative view of an unidentifiable track (No. 55). On the one hand, such speculation is rather meaningless; on the other hand, it prompts the question whether, since there are only sixty-two photographs in the album, a researcher of Barratt's breadth of interest may well have produced other albums, now lost or awaiting rediscovery, as, indeed, this album was until the 1960s. Should any similar albums come to light, the writer would be most grateful to hear of them.

Inevitably, there are a few views that defy ready identification, and several others that have been identified only provisionally. Where the photographs are particularly valuable is in showing that comparison with the same views today reveals vast changes in Hampstead Heath since it was saved for the public. At the time Barratt took his views, the mainly high western area, on its sandy subsoils, was indeed relict heathland, though heavily damaged by long-term sand digging that had intensified to a commercial

scale during the 1860s, while its eastern half, which is today generically included under the title 'Heath' (with a capital 'H'), was actually still farmland, and even today is not, ecologically speaking, heath (with a small 'h'). In very few places was there more than the most basic tree cover, and views which Barratt was able to take across many of its landscapes are today completely obscured by trees. In these cases, while it was clear where Barratt put his camera, I have had to take the 'now' photographs from a place as close as possible to his viewpoint, while affording sufficient visibility to enable the modern visitor to have any chance of locating the spot, or the reader of making anything of the present-day views.

Moreover, the changes have not been gradual over the course of the 140-odd years since the Heath was saved for the public. Conversation with members of the oldest living generation who remembers the Heath shows that their recollection is of a much more open landscape. The main tree growth started during the years of the Second World War, when public open space management was inevitably low on the list of national priorities; indeed, aerial photographs of the Heath at the time show much of it given over to allotments and wheat-growing, and large quantities of the Heath's sand was taken away to fill sandbags, thus altering the topography of some areas even more, while bomb rubble from across London was dumped there after the war. During the post-war management by the LCC and the Greater London Council, much of the Heath's grassland habitat was taken over by scrub, which is now middle-aged woodland. For example, the dense scrub growth between the Hampstead Gate of the Kenwood Estate and the Viaduct Pond now conceals, and arguably threatens the survival of, lines of important ancient oaks, which until the mid-twentieth century were hedgerows dividing the fields of the former farmland. Many of us remember the South Meadow as little more than parkland (in the ecological, rather than the municipal, sense).

Indeed, to slip briefly into philosophical mode, it might be asked whether the pioneers who saved the Heath for us in the 1860s would consider that the spirit of the original injunction of the 1871 Hampstead Heath Act – to conserve the Heath, 'as far as may be, in its wild and natural state' – has been observed as they might have envisaged it a century after, and whether they would have approved or disapproved of the balance and nature of habitats as we know them today. In the 1840s, Sir Thomas Maryon Wilson planted a large number of non-native trees, probably as a part of his plans to disfigure and develop the Heath (fiercely criticised by Charles Dickens, who loved the Heath), while the LCC planted more in 1897 (some of them, such as Planes and Locusts, are still there), much to the anger of local residents. In 1927, the Heath and Old Hampstead Society spoke of 'an excess of trees' and the desirability of restoring 'the beautiful distance views which existed years ago' – a debate that continued during the 1930s and 1950s and still continues today. However, this can only be argued at a theoretical level, since any significant change to today's Heath landscape would be resisted fiercely by the public; and certainly no judgement is intended of the present-day management of the Heath since 1989 by the City of London as both a public amenity and an ecological asset of inestimable value to London. This management, I think is generally agreed, has been exemplary.

I would be happy to hear from any readers who believe that they may recognise where any of the unidentified, or only provisionally identified, views were taken.

The Date of the Photographs

Barratt's choice of subjects and locations suggests that the majority of the Heath photographs were taken prior to the second major acquisition of Heath land in 1889. My initial guess, based on the style of the photographs, was that the collection dated to the decade between 1880 and 1890, and study of the internal evidence of a number of the photographs not only reinforces this belief, but, together with the above evidence, allows an estimate of its date to within a narrow range. The main evidence is as follows:

No. 11, 'Heath Street': The name 'T. R. Keys' can just be made out on the wall of the central building on the opposite (west) side of the street. Thomas R. Keys, florist, is recorded at No. 47 Heath Street in the 1878 and 1882 Kelly's Directories.

No. 19, 'Entrance to Lyndhurst Road': The Lyndhurst Congregational chapel was opened in 1884.

No. 22, 'Heath (North West)' (showing the still-extant 'Two Tree Hill') and No. 29, 'Path over Heath leading to North End', both show the Sandy Heath area still almost denuded by the efforts of Sir Thomas Maryon Wilson to destroy it in the 1860s in order to prepare the way for developing the land. Indeed, given that the land became public property in 1871, it is remarkable that there has been so little recovery of vegetation perhaps fifteen to twenty years later, suggesting that these may be quite early photographs, although the clothes worn by the people in No. 29 suggest the 1880s rather than the 1870s.

No. 24, 'Heath (North West). Heath Keeper's Lodge': This is datable not from the cottage (located just beyond the north-east tip of what is now The Paddock), the origin of which is unknown and which has long since disappeared, but from the still-extant house in the right background, now called Northstead, which was built in 1879, placing the photograph firmly in the 1880s.

No. 25, 'High Street before demolition': the Hampstead High Street improvements were not started before 1885, and completed by February 1888. The photograph must therefore date to no later than *c.* 1884/85.

Nos 30 and 53 show the row of buildings at the east end of Well Walk, known at the time as Foley Avenue, built in 1882.

No. 38, 'View from Parliament Hill', helps us to identify the direction of view, probably from the top of Kite Hill, by the tall spire of St Martin's church, Kentish Town, built in 1865. The Hampstead Railway runs across the far side of the field, and beyond can be seen the estate between Savernake Road and Mansfield Road under construction. A considerable part of the estate remains to be built, but there appears to be somewhat more construction in this photograph than is shown on the 1888 Bartholomew's 9-inch map, dating it to perhaps 1889/90, just after the land in the photograph had been acquired for Hampstead Heath.

No. 44, 'Entrance to Highgate Town', looks from South Grove towards Highgate High Street. Just visible on the still-extant weatherboarded building in the distance is 'F. Weaver'. Frederick Weaver's tobacconist's shop occupied No. 60 Highgate High Street from 1884 to 1894.

No. 46, view across the Vale of Health: the terrace of *c.* 1890 houses seen in the 'now' photograph had not been built at the time of Barratt's view.

No. 56, 'Cottages near "Bull and Bush"', shows the much-photographed old cottages in North End which were destroyed during the Second World War. The 'House to Let' sign in front of one of them bears the name T. Clower. Thomas Clower, a prominent local builder based at No. 27 Hampstead High Street, was born in Hampstead in 1827 and died there on 20 July 1889.

Interestingly, it must be noted that, although Barratt published none of his views in his own work, six were published in Baines' 1890 *Records ... of Hampstead*, though the quality of reproduction was somewhat indifferent: these are No. 10 ('Heath Street'); No. 22 ('Heath, North West); No. 25 ('High Street, before demolition'); No. 26 ('Church Row'); No. 32 ('North End Farm'); and No. 62 ('The Firs, by the Spaniards'). These must therefore predate 1890, and Baines dates No. 25 to 1884.

The cumulative evidence of these photographs therefore suggests that they cover the period 1884–89, and that the album was completed by 1889–90.

THE THOMAS BARRATT
COLLECTION

The photograph titles are those given to them by Barratt. The numbers are my additions, showing their position within the album.

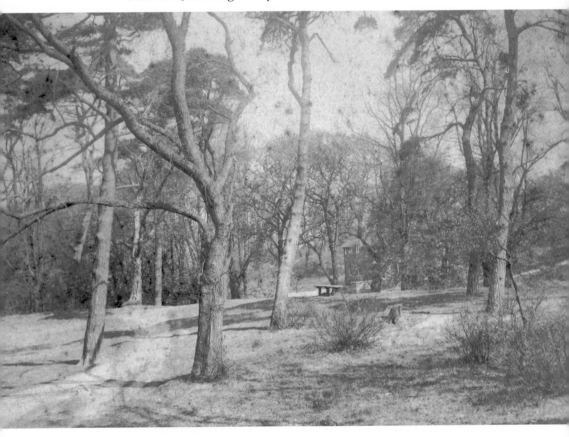

1. Path Leading to North End Avenue

Though Barratt's note suggests that it must be somewhere on the Sandy Heath, it is too imprecise to allow any reasonable guess to be made as to the location. The bareness of the ground hints that it might be in an area once used for sand digging, but the sparse, though fairly mature, trees and the relatively level ground suggest that the view was not taken in the area disfigured only some twenty years previously by industrial-scale extraction. The area appears to be mainly flat, though the topography may drop away in the left distance. Several paths are shown on the 1894–96 Ordnance Survey 25-inch map leading across Sandy Heath to North End Avenue, but the location cannot be suggested with any confidence, despite the presence of the fairly substantial building in the distance.

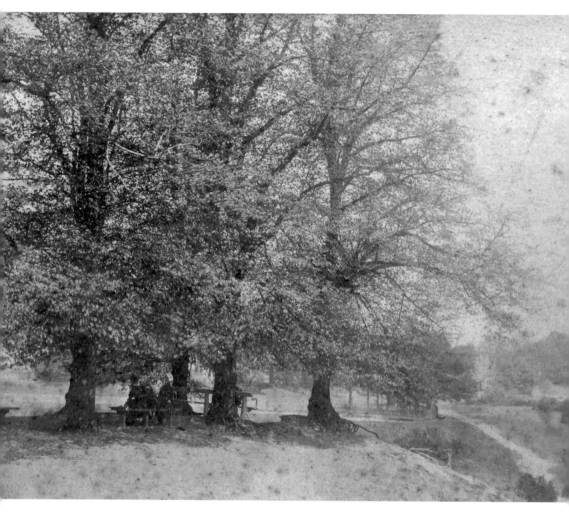

2. General View of Heath

This bears a close resemblance to the 'promontory' of sand and clay left standing immediately north of Heath House and the 'Chicken Run', at the southern end of the 1860s sand diggings on Sandy Heath, even down to the benches and the row of lime trees still a feature of that viewpoint today. However, the topography in the background of Sandy Heath today is somewhat different; the building faintly visible in the distance was a puzzle, as it looks quite close, yet there has never been a building like that on Sandy Heath. The fenced enclosure in the middle distance could have been what is now the Paddock. However, Barratt's description is surprisingly unhelpful, and although a Charles Martin postcard of around 1905 shows the same scene from the opposite side of the 'promontory', it is of no more help in identifying the scene.

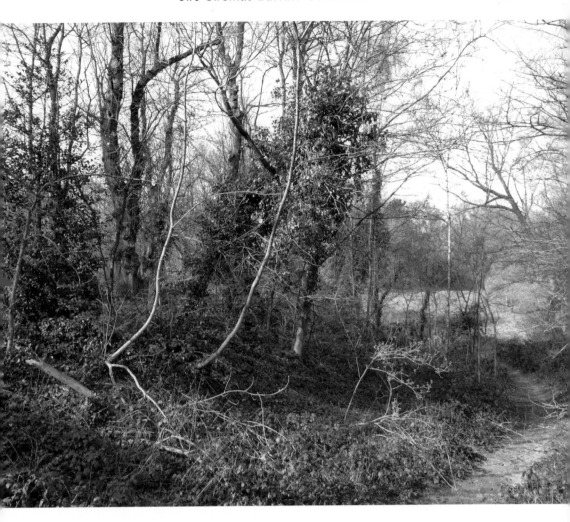

Following long discussion and speculation with Nigel Winder (of the unofficial Hampstead Heath website), and further on-site exploration, it was realised that the fenced enclosure, the distant house, and the bare ground and trees at far right were, in all likelihood, the same view as in Barratt's No. 24, the latter taken from a closer position. It now seems certain that the view was taken from the western edge of Spaniards Road, looking across the aforementioned 'promontory' towards the Paddock. The modern view was taken from high up on the slope of the cutting on the eastern side of the promontory, probably a few feet west of where Barratt stood, as his viewpoint would today be obscured by the young trees now taking up much of the view. The topography in the middle distance is today more level, owing to substantial dumping of Second World War bomb rubble over the area. This view should therefore be studied in combination with view No. 24.

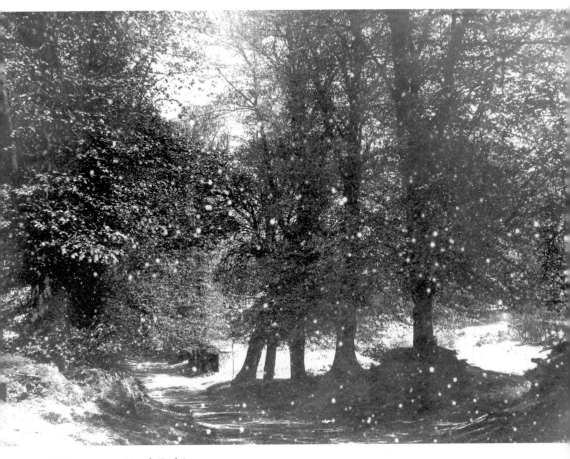

3. Entrance to North End Avenue

This view is easily located, at the very top of the north-south slope down North End Avenue, at the point where it starts to turn west to take the walker to North End Road, and remains surprisingly familiar. A low, shed-like structure stands halfway down on the right side of the Avenue, where a fence today separates private from Heath land, and it appears, rather remarkably, that most of the lime trees present in Barratt's view still survive today. They look at least 50–75 years old in Barratt's photograph, suggesting that, unless they were replanted not long after, to enable them to grow to their present size, they are now in the region of 200 years old.

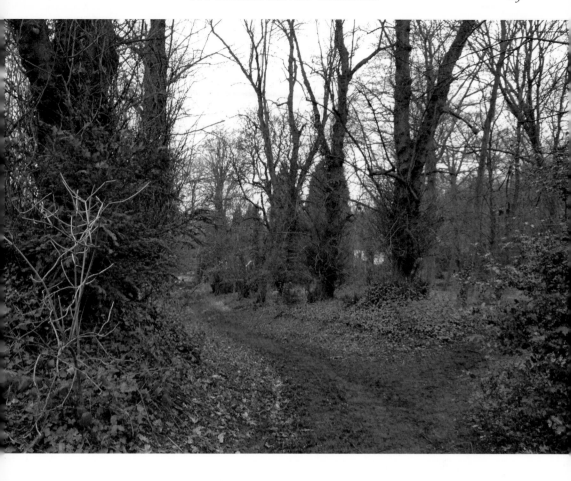

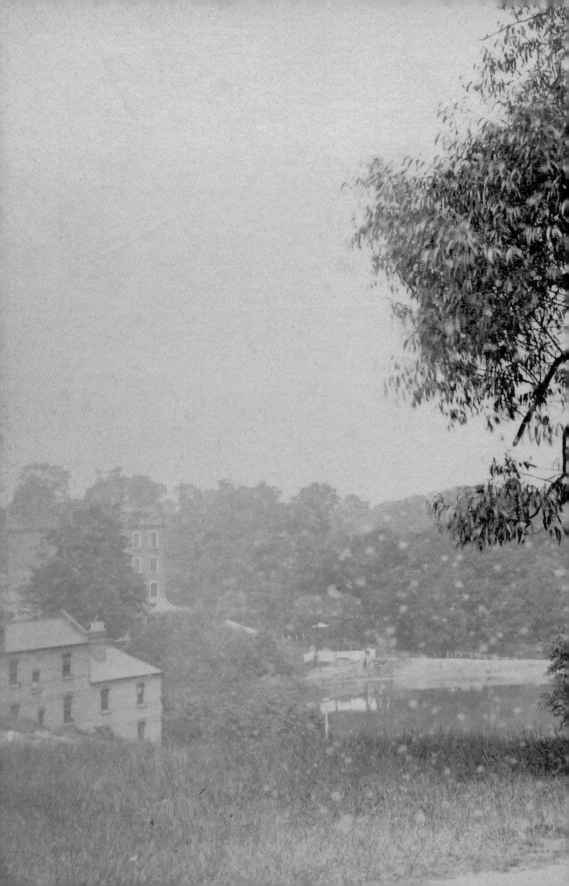

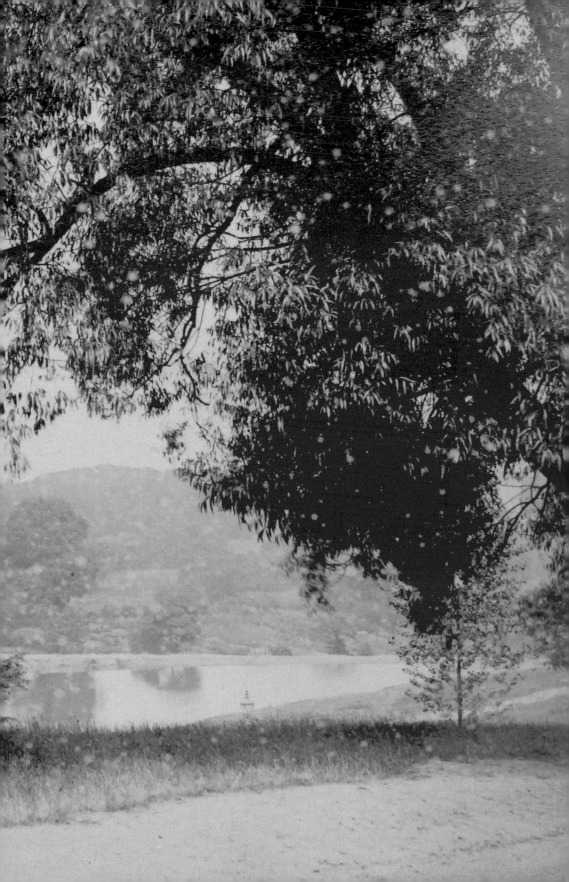

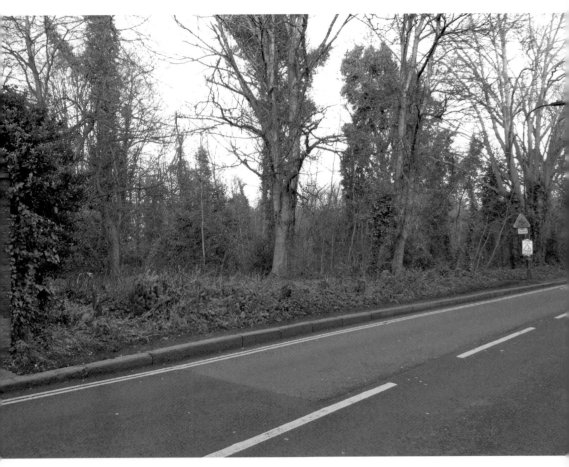

***This page and previous:* 4. Vale of Health from East Heath Road**
Both Barratt's and later views show that, until well into the twentieth century, the area east of East Heath Road carried little vegetation, affording good views to the Vale of Health and beyond, the present dense screen of trees mainly developing from the mid-twentieth century. Barratt's viewpoint must be at a location that allows a view both of buildings in the east of the Vale of Health Village and the Pond itself, from its western tip to what was then the Vale of Health Hotel. The location is, therefore, almost certainly close to the top of East Heath Road, by the junction with the southern boundary wall of Bellmoor, Barratt's own home, which is in fact visible at the extreme left of his view and still exists.

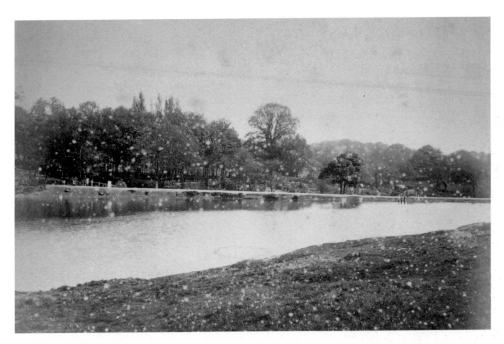

5. Vale of Health Pond

This view is, in principle, easy to locate, as it clearly looks eastward from the southern bank of the Pond – created as a reservoir in 1777 from former marshland – towards the causeway bounding the eastern edge of the Pond. However, a combination of dense bramble growth along the western half of the Pond's south bank, and the undoubtedly considerable changes since Barratt's time in the topography around the Pond through natural and human erosion, makes the exact viewpoint difficult to locate today, and the position chosen for the 'now' photograph approximates to Barratt's viewpoint.

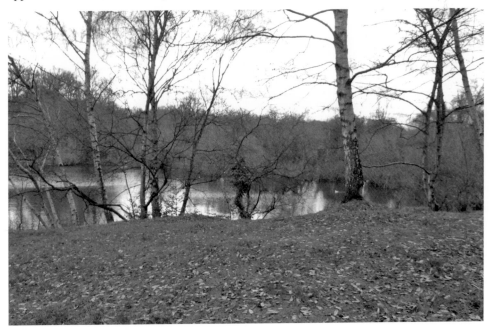

6. Vale of Health from Upper Heath

Barratt's view was taken at a point a few yards down what is now a well-worn track on the slope from the still-extant 'Constable's Firs', immediately east of Spaniards Road and the Battery Track, down to the Vale of Health. Although trees have obscured, and later building altered, the general roofscape of the Vale of Health, the prominent rendered, ridge-roofed house in Barratt's view still stands out today as a landmark. The location of the photograph can therefore be closely established. The 'now' photograph has been taken some yards north of Barratt's, in order to give visitors a wider view of the area and fix their position by the bench there today, just below the top of the slope; Barratt's position was a few yards downhill.

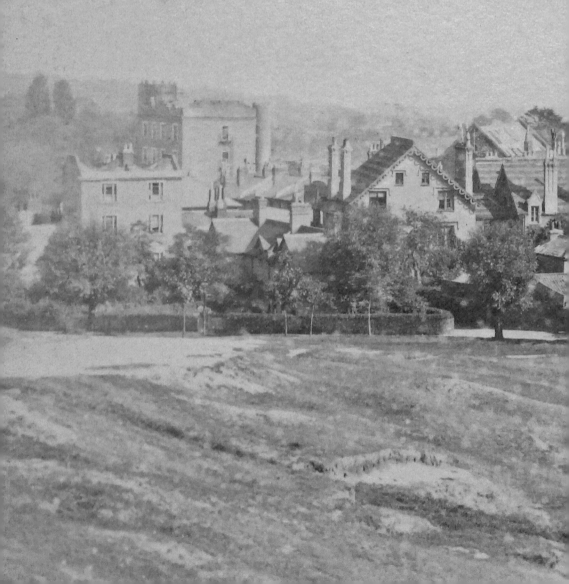

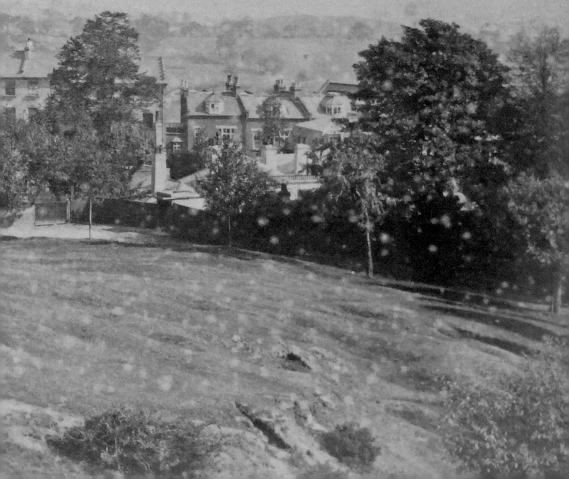

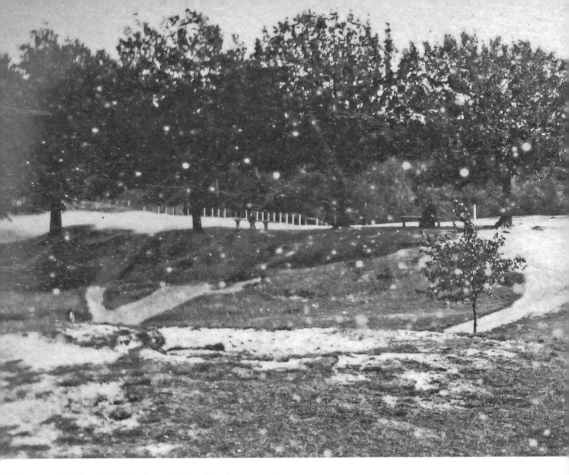

7. Vale of Health from Lower Heath

One wonders why Barratt took this rather dull view from just below the Vale of Health Pond causeway towards the pond (not visible). The old castellated Vale of Health Hotel can be seen in the background on the right. The wide eroded track leading down the slope and forking left and right in Barratt's view is still kept open today through public use, though now only the track to the right exists, which is extremely muddy in the winter. The area beyond the track is now heavily overgrown, so the 'now' photograph was taken from the track itself, to the far right of Barratt's view. The familiar wellingtonia now growing at the bottom of the slope will enable seekers to find the location that, as with the majority of Barratt's views, has been transformed through vegetation growth.

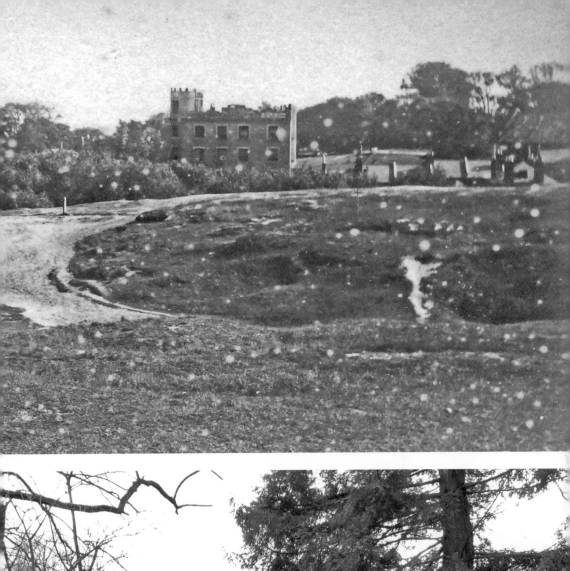

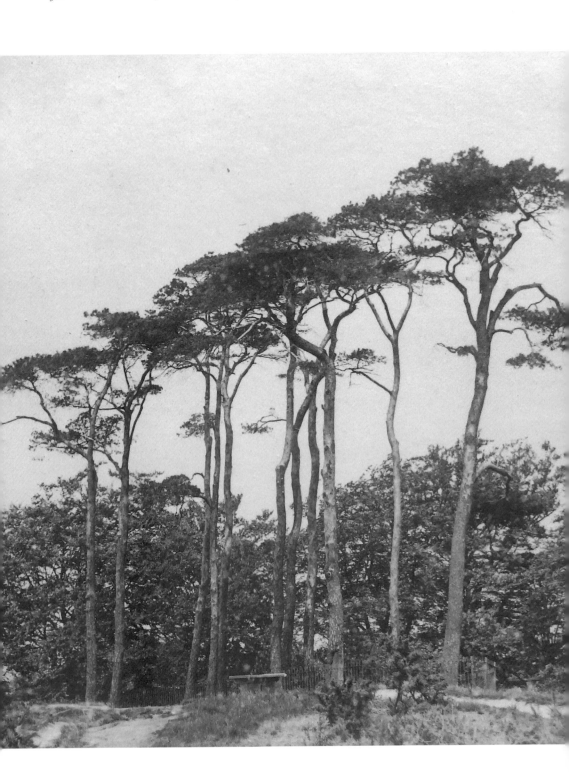

8. Firs on West Heath

These are the North End firs (actually Scots pines), a long-noted feature of the area and much photographed during the Edwardian postcard era. This view is barely possible today, given the transformation of the area from open heathland in Barratt's time to secondary woodland today. The original 'firs', with their photogenic sculptural form, are long gone, but two stands of Scots pines still exist close to each other on the slopes above the track leading from North End Road along the southern edge of Golders Hill Park, to the Leg of Mutton Pond. The problem today lies in deciding which of these stands, each on its eroded outcrop of sand and clay, the remains of large-scale eighteenth- and nineteenth-century sand digging, was the subject of Barratt's photograph. Given the disappearance of the original trees, erosion from weathering and millions of visitors over the ensuing 120+ years, and the dense vegetation now present, the exact viewpoint is difficult to locate with certainty. However, careful study of the topography leads me to conclude that the photograph was taken from a point about 20 yards south of the track, where there is no path today, looking eastwards at the bottom of the slope on which the westernmost group of pines stands, and maybe some 75 yards west of North End Road.

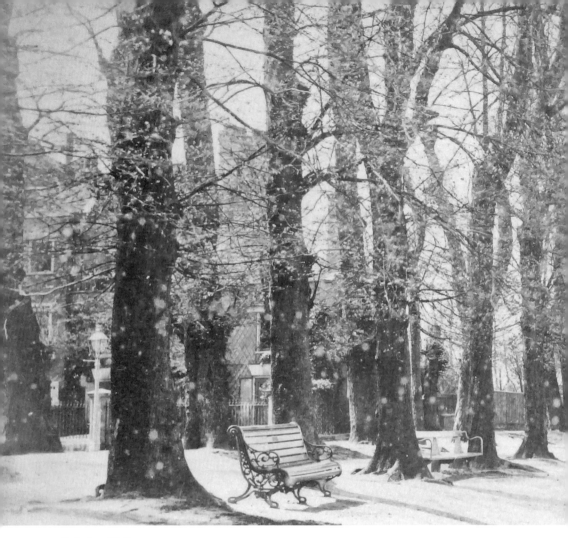

9. Judges Walk

This view is little changed today, even down to the street lamp that still appears to stand in the background to the left of the tree at far left. The viewpoint is at the eastern end of the row of limes marking the southern side of Judge's Walk, the roadway behind the limes, looking south-west towards Branch Hill in the distance with the slope down to Judge's Hollow on the right. The modern bench enables the spot to be found easily. In the earlier nineteenth century it was known as Prospect Walk, and then as Upper Terrace Avenue; the current name may derive from two Lord Chancellors who lived nearby at Branch Hill Lodge. There were originally three rows of trees; Barratt's view shows what appears to be a fine double row. As with North End Avenue, the size of the lime trees (and one horse chestnut) today suggests that they are the same trees in Barratt's view, which themselves look quite mature, suggesting that they, too, may now be some 200 years old. In 1903, Caroline White referred to the walk's 'almost hopeless decadence, the trees pollarded and lopped out of all resemblance of their old forms, and more than three parts of their numbers dead', but Edwardian and later postcard views suggest that her pessimism was somewhat overstated.

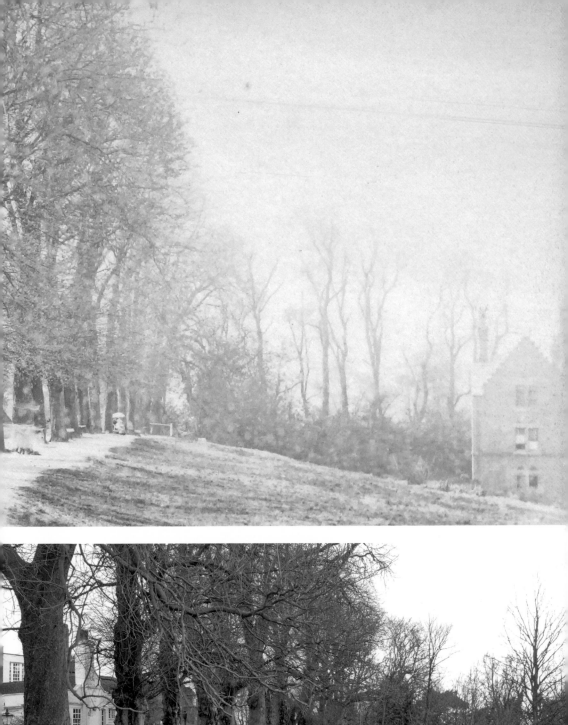
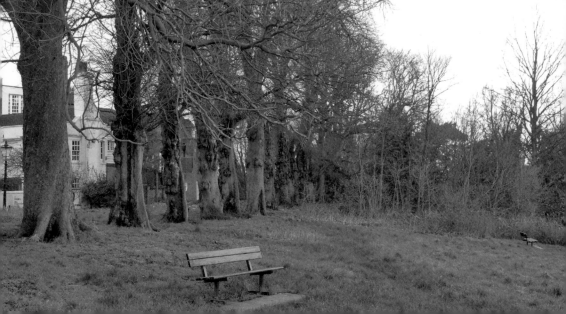

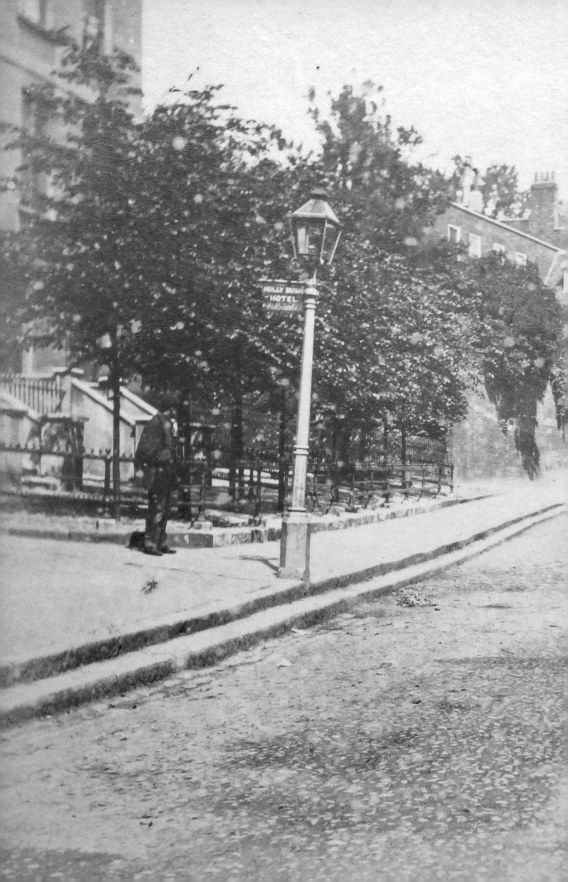

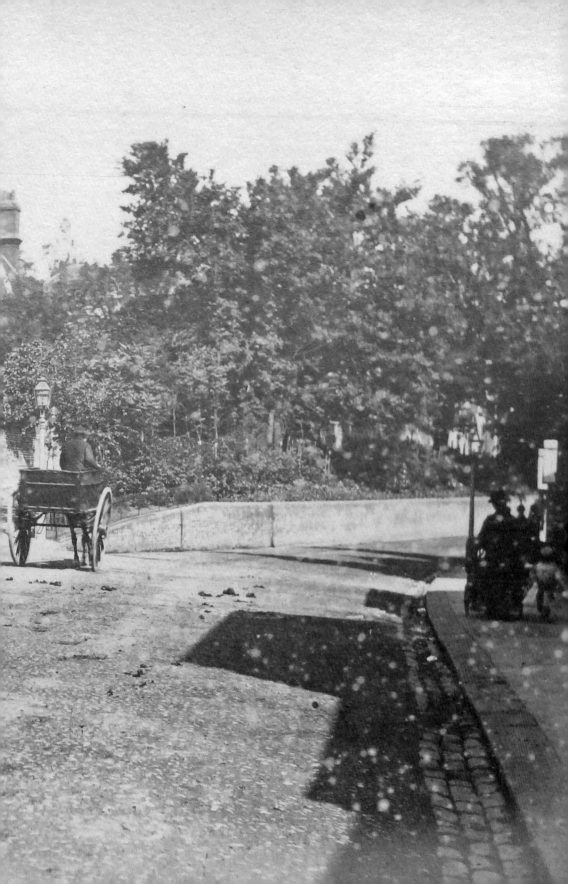

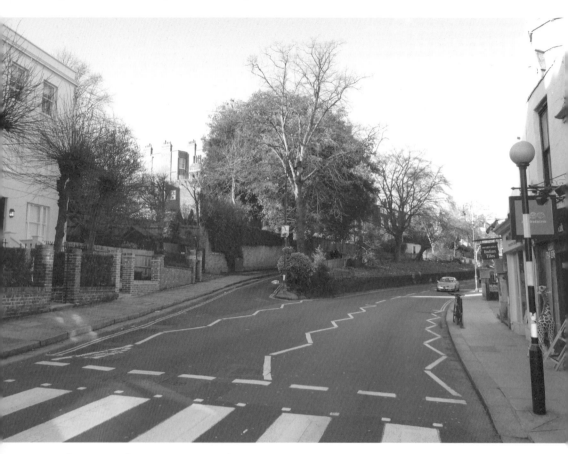

This page and previous: **10. Heath Street**

The exact position of this northern view up Heath Street is marked today by a zebra crossing. A few yards up the Mount, in the left distance, is the setting of Ford Madox Brown's famous 1868 painting *Work*. The scene is remarkably unchanged, even to the unusual double-kerbed pavement on the west side of the street. This view was published on page thirty-two of Baines' 1890 *Records ... of Hampstead*, dating it to no later than *c.* 1889.

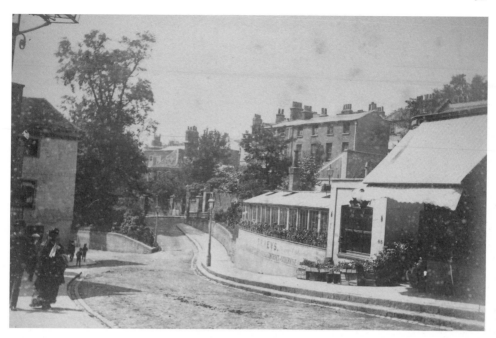

11. Heath Street

This view looks southward down Heath Street, showing the upper end of the Mount. Few of the buildings in Barratt's view remain, other than the house in the background above the Mount, although this is now obscured by a later twentieth-century building. Nevertheless, the view remains entirely recognisable. Barratt's view appears to have been taken from the southern corner of Elm Row. The sign on the building at centre advertises 'T. R. KEYS'. Thomas Robert Moore Keys, florist, is shown at No. 47 Heath Street (lower down, by the junction with Holly Hill) in 1878, at High Street, Hampstead in 1882, and at No. 28 Hampstead High Street in 1896, suggesting an 1880s to early 1890s date, although it is logical to suggest that it was taken in the same session as No. 10. Keys was an active member of the Hampstead Naturalists' Club.

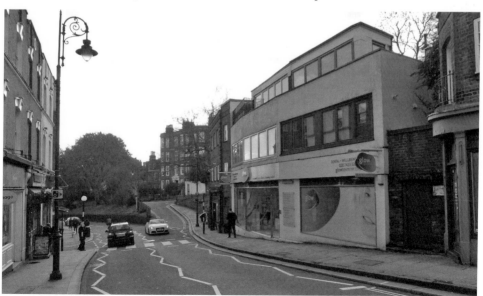

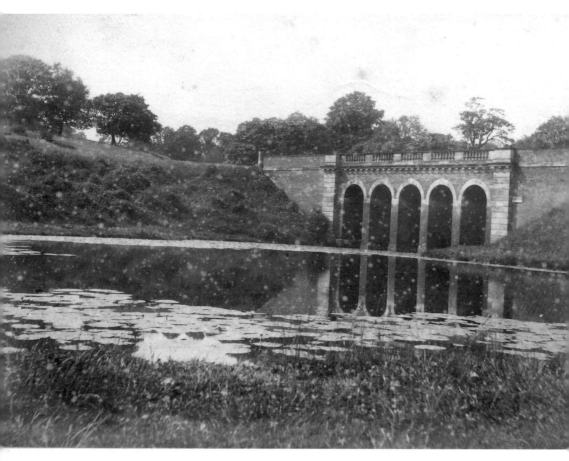

12. Viaduct, Lower Heath

A scene instantly recognisable today, and effectively unchanged other than the advance of woodland across former fields to the edge of the pond. Though a much-loved feature of the Heath today, the viaduct is actually one of the most visible elements of the efforts by the then-owner of the land, Sir Thomas Maryon Wilson, to destroy the Heath. Built in 1845, it carried a road running from Jack Straw's castle to the southern end of the Heath, intended to serve the vast East Park Estate between Kenwood and the Hampstead ponds, which Wilson proposed covering with large villas; this road, and the viaduct, are thankfully all that survives of Wilson's thwarted efforts, and for many years after the viaduct was known as Wilson's Folly. At the time of Barratt's photograph, it would only have been about forty years old and looked relatively newly built. When you stop to admire the rustic views from the viaduct today, think too about what might have been, were it not for the efforts of the early campaigners to save the Heath.

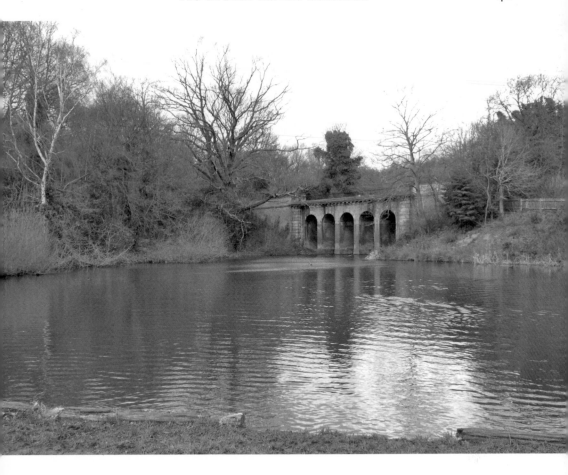

***This page and previous:* 13. Millfield Lane, Highgate**
A comparison of the topography of Barratt's view with that on the ground today, together with the open paling fence in his photograph on the western side of the land (now replaced by railings) and a solid fence on the eastern side (as it is today), makes the likely location of Barratt's photograph the modern redeveloped Fitzroy farm site. Looking south from this location, the topography along the trackway looks very similar. The sunlight falling on the lane from the western (right) side, which would formerly have been less densely populated by trees and surrounds what is now the bird sanctuary and ladies' ponds, also suggests that the camera is looking south. The lane dates to at least the sixteenth century, and may be a medieval trackway originally leading from the city to the Bishop of London's hunting lodge, the foundations of which still survive on Highgate Golf Course.

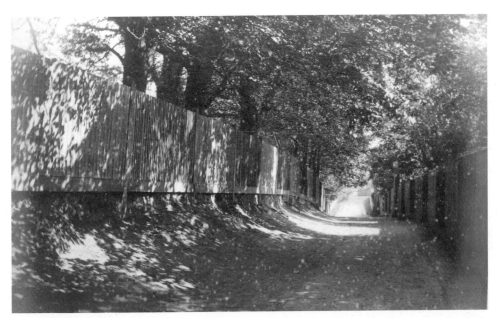

14. Frognal Lane. Footpath Between Oak Hill Park and Branch Hill. Grounds of Branch Hill Lodge on Left, Montagu Grove on Right. This has Been Named 'Oak Hill Way', 1909
It is difficult to pinpoint the camera location today in this much-changed lane, which is also privately owned and inaccessible. The modern photograph was therefore taken at the eastern entrance to the lane, looking eastwards towards Branch Hill, with what would have been the grounds of Branch Hill Lodge on the left and Montague Grove on the right. It is therefore in the same direction as Barratt's, although Barratt's view appears to be considerably further to the west. Most of Oak Hill Way is now private property, so the 'now' view is purely indicative, to preserve at least the spirit of Barratt's.

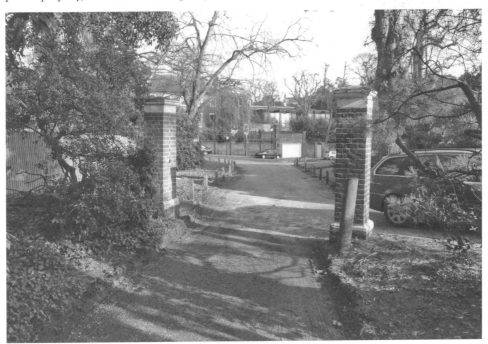

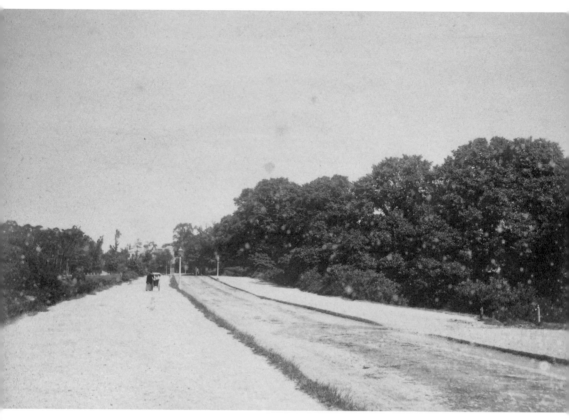

15. Spaniards Road

The direction and approximate location of Barratt's view is quite clear. In the far distance, under magnification, the Spaniards firs, the white rail fence along Sandy Road and the buildings by the Spaniards Inn can be made out, while the gorse starting to recolonise the Sandy Heath can just be seen at the far left. Sandy Heath had been denuded of vegetation during the 1860s sand digging. While it is difficult to locate Barratt's viewpoint precisely, it is perhaps about two-thirds of the way along the road towards the Whitestone pond. While the pedestrian shoulder on the left looks much wider than it currently does, this is because the road has been widened and vegetation encroaches onto it today.

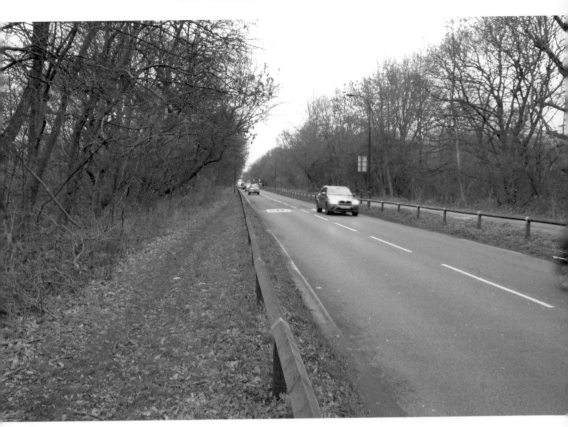

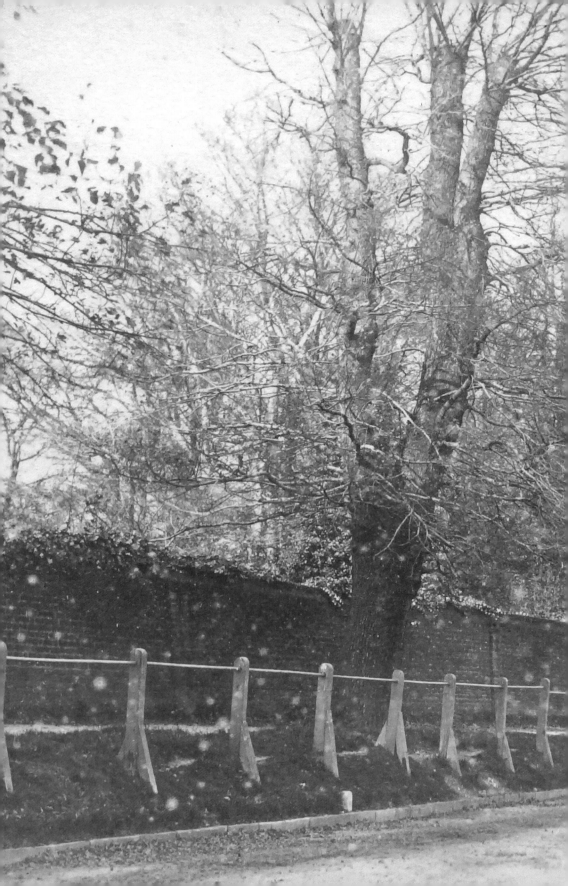

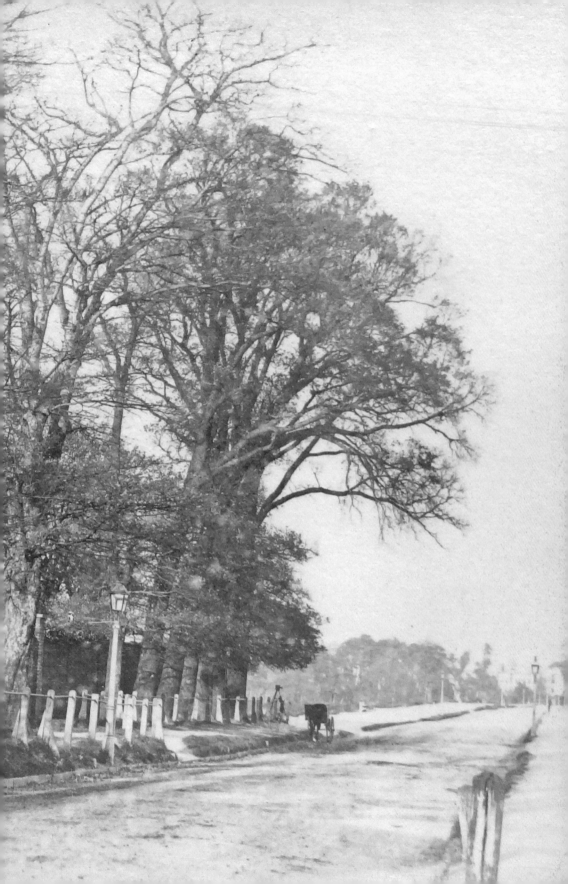

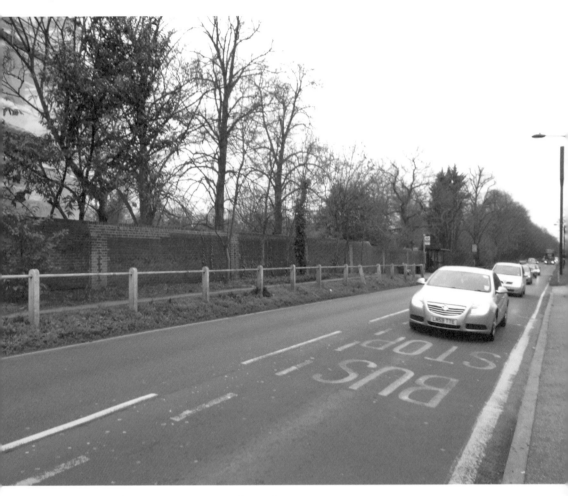

This page and previous: **16. Spaniards Road**

Barratt's viewpoint is still easily recognisable as being exactly by the present-day southbound bus stop on the east side of Spaniards Road, near the Whitestone pond looking north, with the garden wall of Heath House visible in both views. The large tree on the opposite side of the road was the famous 'Eared Elm', with an ear-like boss (not visible in the photograph) illustrated by Barratt in his *Annals*. It was felled in 1906, and was the subject of a lecture by Sir Samuel Wilks to the Hampstead Scientific Society in 1907. The absence of vegetation on the Sandy Heath side of the road from the sand diggings of twenty years previously can easily be seen in Barratt's view, contrasting noticeably with the dense tree growth covering Sandy Heath today.

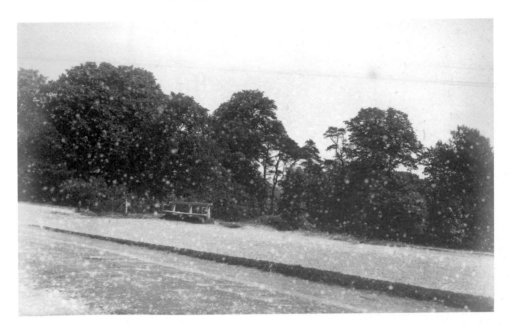

17. Spaniards Road

Though easily locatable, one wonders why Barratt took this rather uninformative and dull photograph. Given his identification, and the presence of at least two Scots pines in the middle of the horizon, it may be deduced that the view looks towards the northern end of the long row of pines known as 'Constable's Firs', which is still a feature of the skyline today on the far side of the wide track passing through the Upper Fairground and Battery. The viewpoint is exactly by the present-day northbound bus stop on the west side of Spaniards Road, outside the Heath House garden wall. There is still a public bench in the same location, though the view today is marred by the battery of telecommunications equipment; while unarguably necessary, it could surely be better designed, particularly in such sensitive locations.

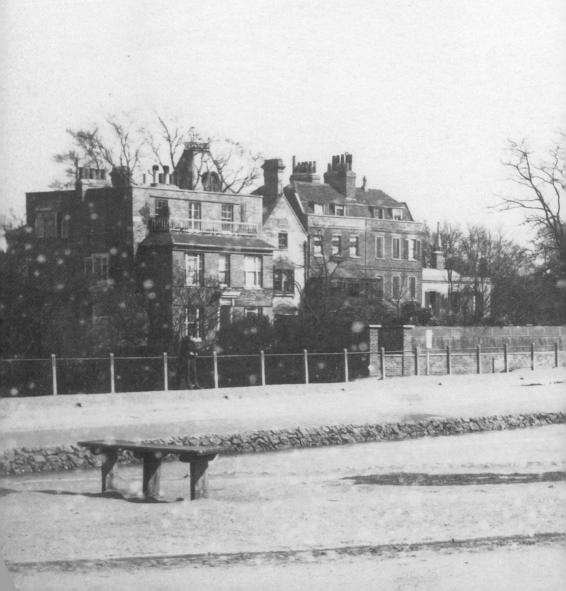

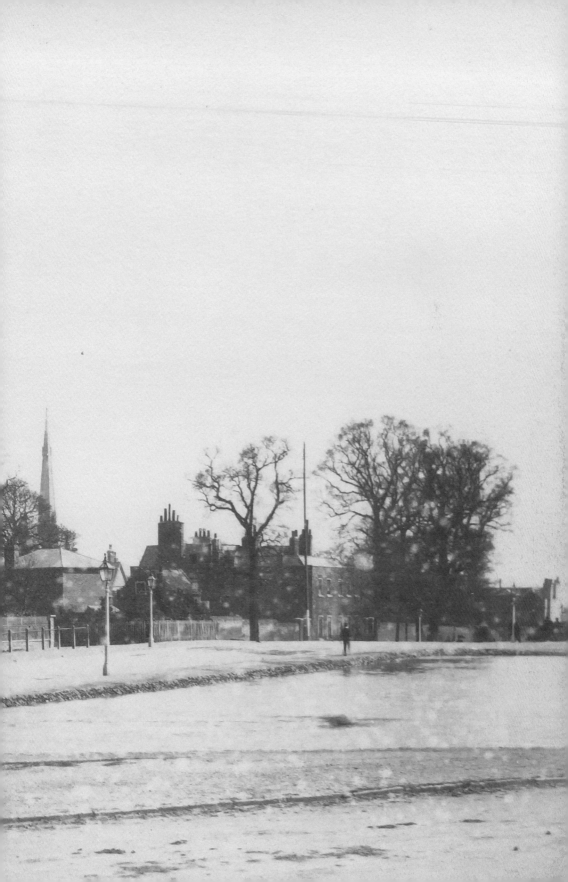

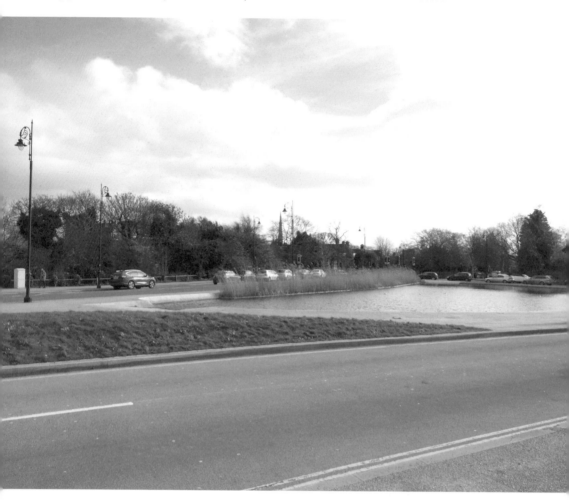

This page and previous: **18. Whitestone Pond**
This view looks south-east from the west side of Whitestone Walk across Whitestone Pond. Barratt's
Annals shows a drawing from a similar viewpoint, titled 'Ludlow Cottage and The Lawn, Hampstead
Heath', with what is probably Gangmoor at the left; these buildings, part of a group clustering round
the pond at the highest point in London, still exist, though today obscured by trees.

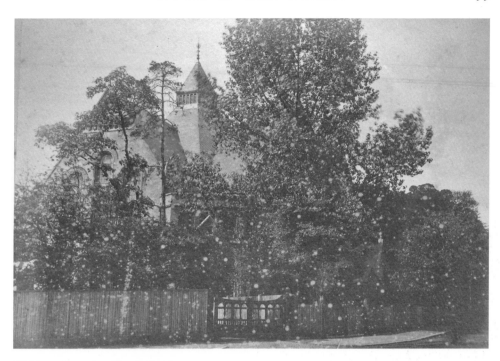

19. Entrance to Lyndhurst Road
This shows the then newly built Lyndhurst Road chapel, by noted architect Alfred Waterhouse, among whose outstanding works is London's Natural History Museum. This view, taken from the southern corner of the Rosslyn Hill and Pond Street junction, cannot date to earlier than 1884, when the chapel was built, and evidence from the rest of the album suggests that it must have been taken before 1889/90.

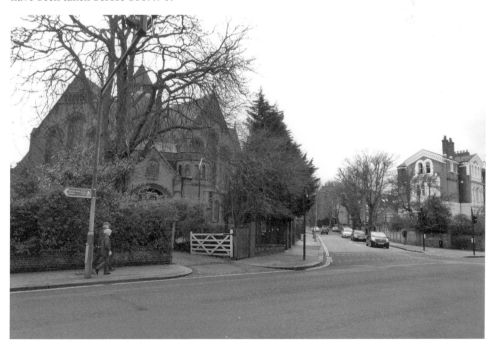

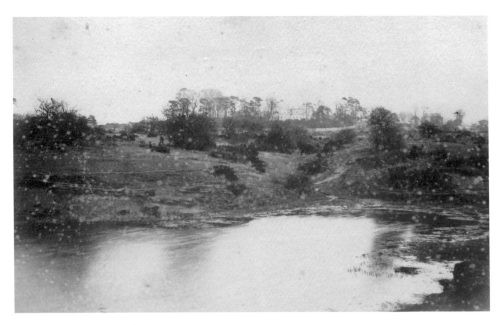

20. Leg-of-Mutton Pond

Barratt's view, along with other early-twentieth-century views, shows that the West Heath area was mainly treeless at the time, covered only with gorse scrub and still very much a true heath. His view looks eastwards across the pond from its western bank, and so sparse is the intervening vegetation that the line of Constable's Firs on the far side of Spaniards Road can easily be seen in the background. Barratt's actual view, along the southern bank of the pond, would today show nothing but dense vegetation, so the modern view was taken around 15 yards to the east of Barratt's viewpoint to enable visitors to locate the spot. The view today, however, is simply of a lake surrounded by trees. The pond itself was created in about 1816 as part of works programme for the parish poor.

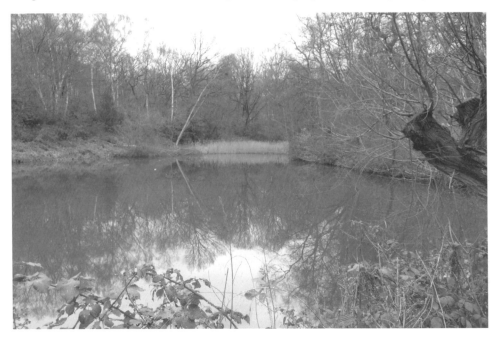

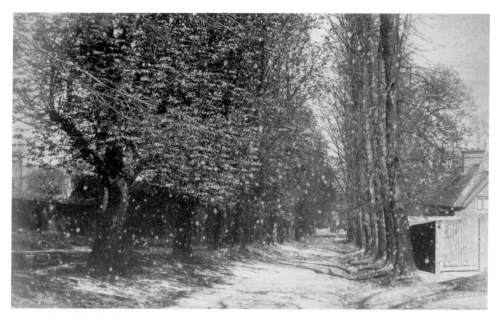

21. North End Avenue

Barratt's scene appears misleadingly level, given the slope of most of the track, but this is an illusion, and the viewpoint can be confidently located some distance down the slope from view No. 3, with the corner of the fence demarcating the privately-owned land in both views. Visible at the far right of this view, with a single-storey house beyond, is probably the lodge of what is today Northfield House. On the left, in both 'then' and 'now' views, the garden wall of the eighteenth-century Pitt House can be seen. It was not demolished until 1952, but is not visible in Barratt's photograph behind the screen of trees. Almost none of the original rows of trees from the left (horse chestnuts) or right (limes) survive, except for two limes in the modern photograph that must be at least 150 years old. The view today is much changed yet very recognisable, and the now-quiet pathway once carried the road from London to St Albans, until the North End Way cutting was dug in the early eighteenth century.

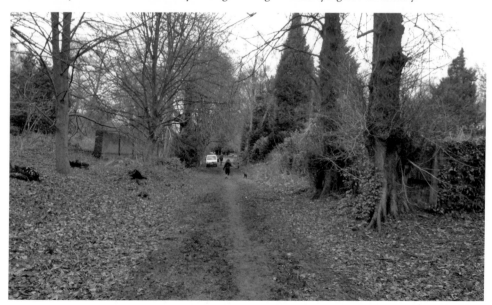

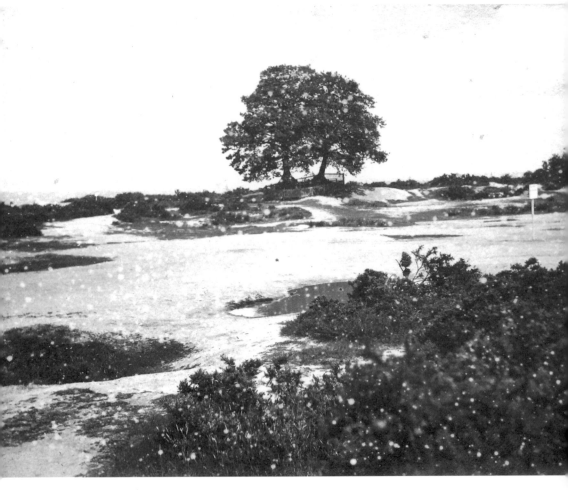

22. Heath (North-West)

This scene would be unrecognisable today, were it not for the two magnificent veteran oaks that survive today in approximately the middle of Sandy Heath, on what is known as Two Tree Hill. The 'Hill', however, is no more than a large pedestal of sandy clay left when the rest of the area was destroyed by sand digging in the decades leading up to, and particularly during, the 1860s. By the 1880s, when Barratt took his photograph, the area was clearly still only in the early stages of recovery, and the two oaks, thought to be well over 300 years old today, were virtually the only trees left standing on what is now Sandy Heath. They are almost miraculous survivals of the devastation, and we must be grateful that they, at least, were spared from the unsuccessful efforts of former owner of the Heath, Sir Thomas Maryon Wilson, to develop his land.

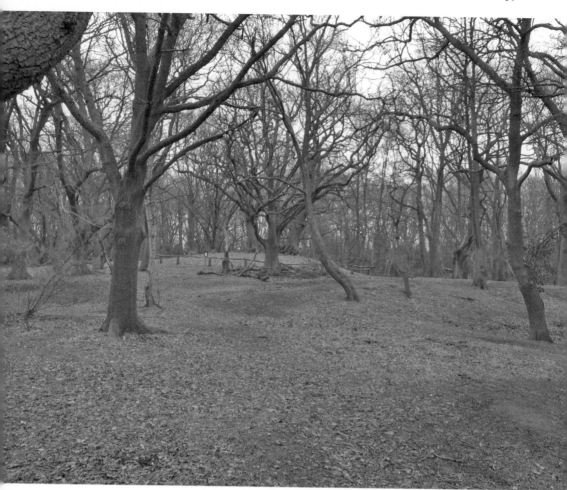

Later photographs show that it was not until the early decades of the twentieth century that Sandy Heath began to recover and even develop the character we know today. From the relative positions and shapes of the two trees, Barratt evidently took his view from a location probably a short distance north of photograph No. 50, close to the western side of Sandy Heath, with the Spaniards Road ridge in the distance, and what are almost certainly Constable's Firs in the far right distance. The almost complete absence of vegetation, however, suggests that it could have been taken no later than the 1880s, and this is confirmed by the fact that the view is published on page 145 of Baines' 1890 *Records … of Hampstead*, thus dating it to no later than *c.* 1889.

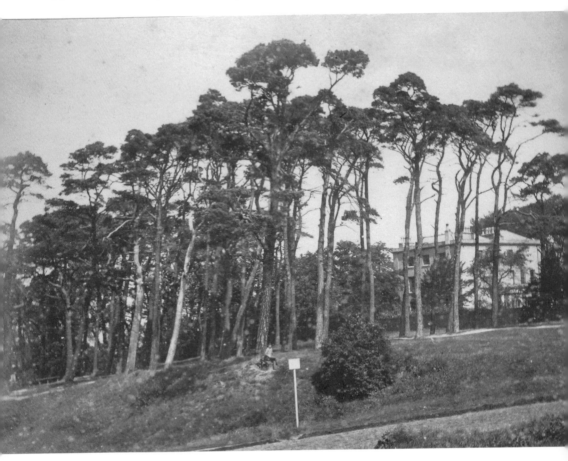

23. Firs (Near Spaniards)

These are the so-called 'Turner's Firs' near the Spaniards, immediately south of the Spaniards Inn. They are not named after the artist, but after the local mid-eighteenth-century landowner, John Turner, who planted them. John Turner was a London merchant who lived at The Firs, the 1734 house seen in the background of Barratt's view, and for whom the nearby Turner's Wood was named. The house still survives, though much altered, and is a part of what is today called Spaniards End. Sandy Road crosses the foreground, leading from North End to Spaniards Road, which is just out of the photograph on the right. Page 191 of Barratt's *Annals* has a similar photograph of the same scene, taken in 1909 and showing fewer trees.

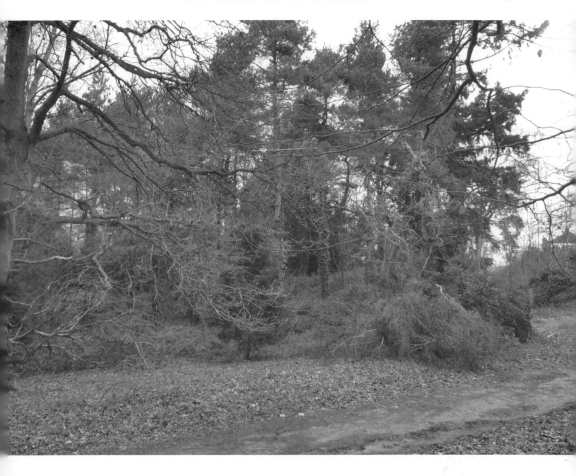

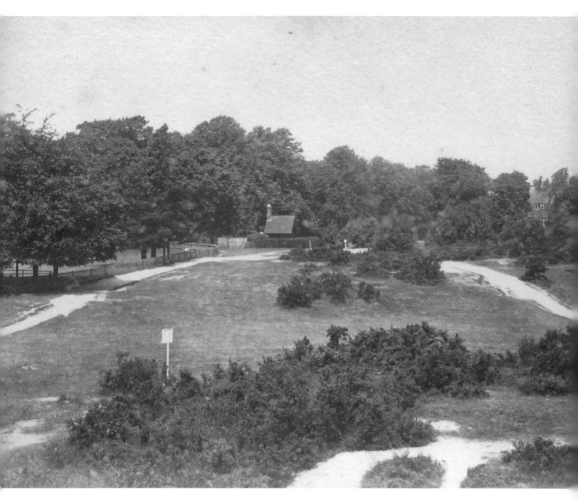

24. Heath (North-West), Heath Keeper's Cottage

Surprisingly, the location of this well-known view, the subject of several Edwardian postcard photographs (one describing it as being at North End) appears to have been forgotten. Even detailed maps of the time are unhelpful. It was suggested to me that it might be close to the Walter Field Memorial Fountain on the Heath Extension, as a fountain is visible close by the cottage in several views, including this one. However, that fountain is very different in design, the topography of the Heath Extension area does not seem to me in any way to fit the location, and the Heath Extension land was not only not farmland at the time, but was not incorporated into the Heath until 1907, some twenty years after Barratt's photograph. Caroline White adds to the uncertainty by referring, on page 164 of her book, to 'one of the Heath-keeper's lodges'. However, Barratt's title suggests that the location must be somewhere west of Spaniards Road, and the 1894–96 Ordnance Survey map shows a small building in an enclosure just to the east of the top of the North End Avenue, immediately north of the Paddock.

The two real clues in Barratt's view are that there is a two-storey house among the trees in the background on the right, and a paling-fenced enclosure in the left background. There are also two signposts, one in the foreground and one to the right of the cottage, rather reminiscent of Corbauld's famous 1883 Punch cartoon showing the forest of signage on the newly acquired Heath land, hinting that it may be within the area of the original 1871 acquisition.

This enclosure is the same one as that described in view No. 2, today called the Paddock. A careful exploration of the ground where the building in the 1894–96 map stood (it is almost certainly the cottage), shows that no trace survives of it or the fountain. Its site is now an ivy- and scrub-filled depression in the ground, perhaps from the Second World War sand extraction that altered the topography of much of the area.

The house at the far right of Barratt's view remained a puzzle until it was realised that the changes in the topography over the past century, and particularly tree growth, had altered both the view and our perception of distances. Standing on the site of the cottage today, the house in Barratt's view is still there and would be clearly visible, were it not for the trees. Originally called Northfield, and accessed from the east side of The Avenue, it was built in 1879, as is helpfully marked on its rainwater gutter heads. It would therefore have been five to ten years old in Barratt's view. The house was renamed No. 1 North End Avenue when it was divided into two dwellings, and is now called Northstead. In Barratt's photograph, the massive chimneys visible today do not appear to have been completed, but the mansard and first-floor windows retain the same configuration. It is therefore certain that view No. 24 was taken from the north end of the 'promontory' north of Heath House, shown in view No. 2. Barratt's view does not show the steep slope at its northern edge, and shadow and vegetation obscure the slope in the modern photograph.

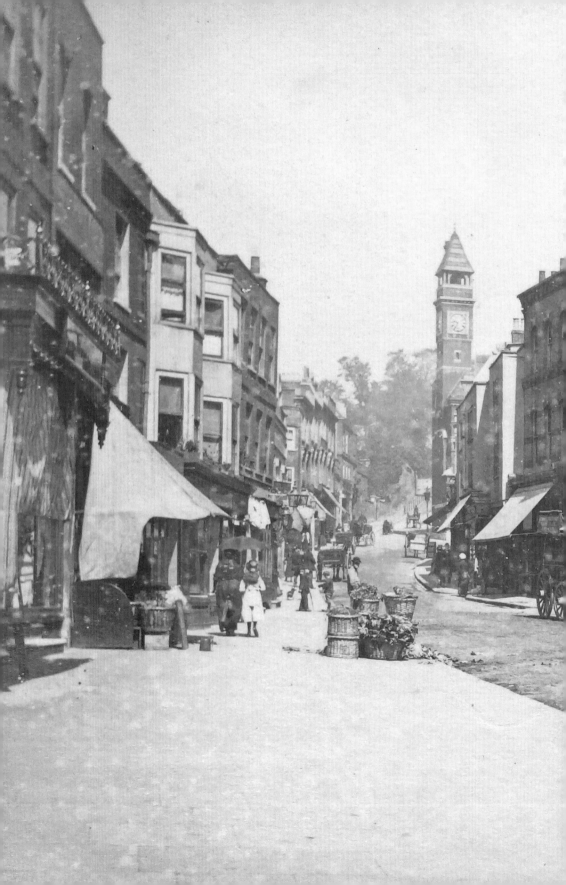

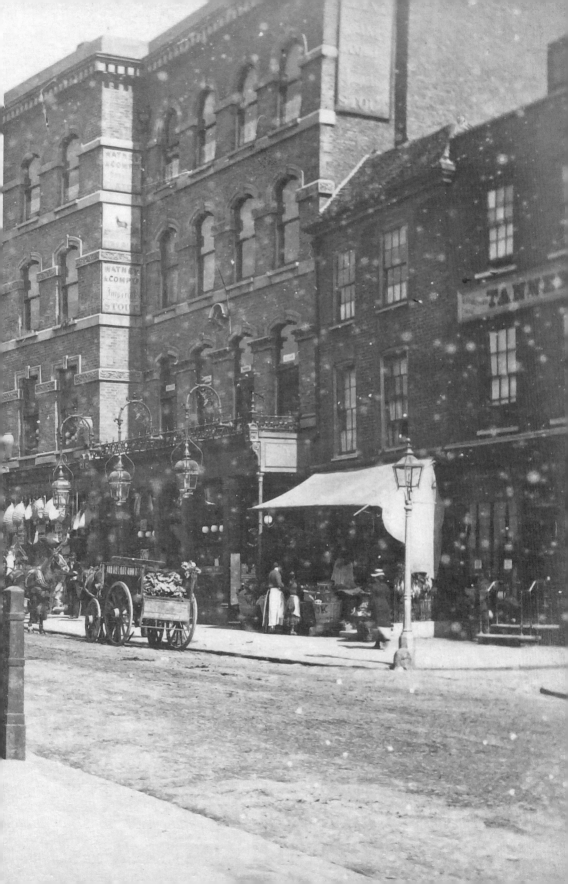

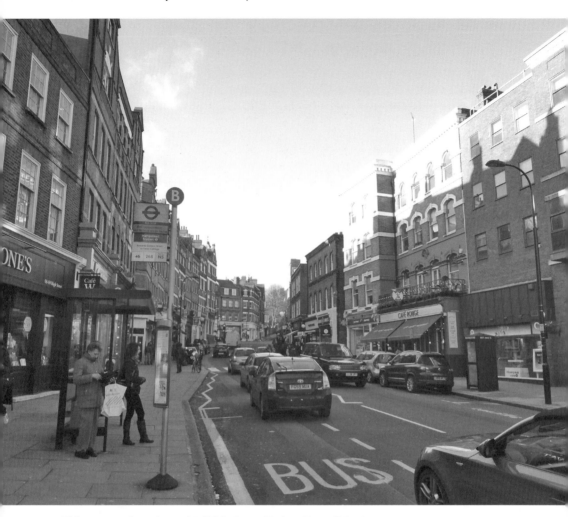

***This page and previous:* 25. High Street (Before Demolition)**
The location of this north-west view up the western side of Hampstead High Street (*see previous page*) can be pinpointed exactly, outside what is today Waterstone's Bookshop. However, this superficially familiar scene has, in fact, changed significantly today. Few of the buildings present in Barratt's time remain, other than the Victorian buildings on the north-east side and the tower of the fire station at the end of the street. Improvements to Hampstead High Street (details of which can be found in Baines' 1890 *Records ... of Hampstead,* pages 192–194) were not started until 1885 and were completed by February 1888. The area was radically altered by the clearance of decaying alleys and yards, of which a number of watercolours fortunately remain. Heath Street and Fitzjohn's Avenue were linked as a through route, and the High Street was also widened, with the properties on the west side north of No. 70 being demolished. The destruction of much of Hampstead's quaint, if decrepit, heritage prompted considerable criticism at the time. This is another of Barratt's views published in Baines' 1890 *Records ... of Hampstead* (page 469), where the photograph is actually dated 1884.

26. & 27. Church Row

These two photographs show essentially the same scene, one slightly closer to the church than the other. The trees, still quite small saplings in Barratt's view, were planted in 1876. Other than the replacement of the houses at the far right of Barratt's view in 1898 by Gardnor Mansions, central Hampstead's first block of flats, the scene is today essentially unchanged from Barratt's time and had been for perhaps a century before. No. 26 is another of Barratt's views published in Baines' 1890 *Records ... of Hampstead* (page 336), dating it to no later than around 1889.

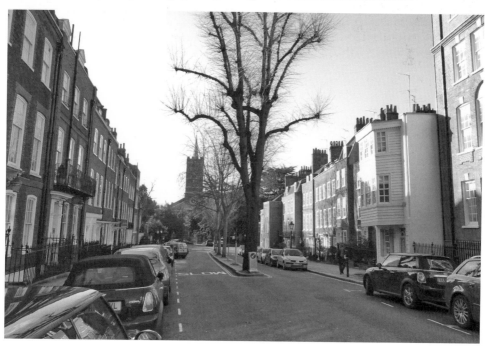

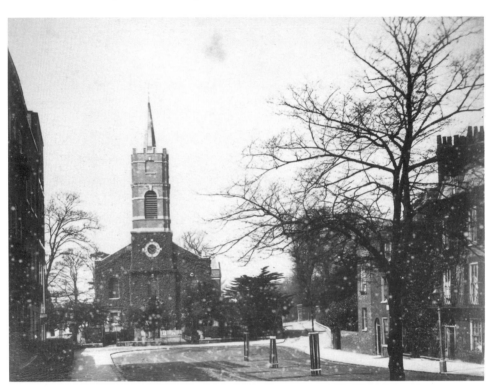

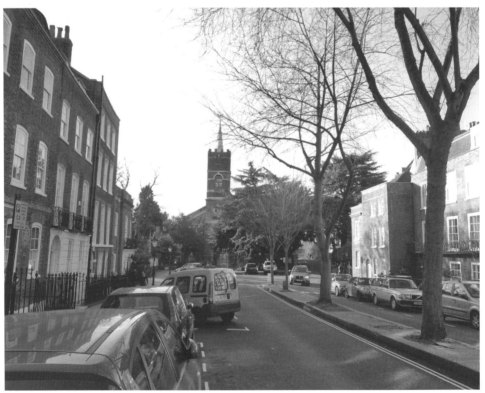

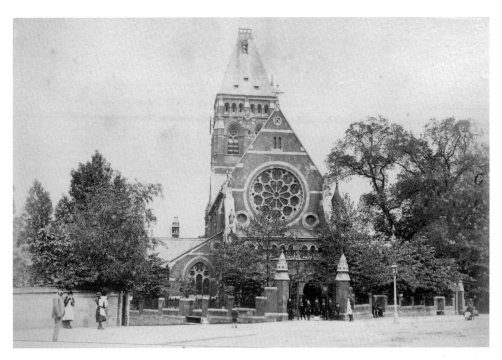

28. St Stephen's Church

This view of St Stephen's church on Rosslyn Hill, built by Samuel S. Teulon in 1869, was taken from the north corner of the junction with Lyndhurst Road, so the church was some twenty years old at the time of Barratt's photograph. The view is very recognisable today, the main change being the massive bulk of the Royal Free Hospital, Pond Street, in the background. An indispensible asset for north London, it is unfortunate that it could not have been designed somewhat more sensitively to the location.

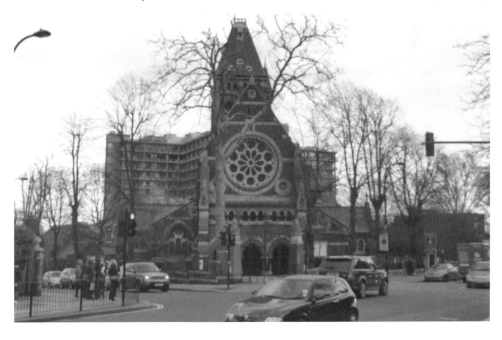

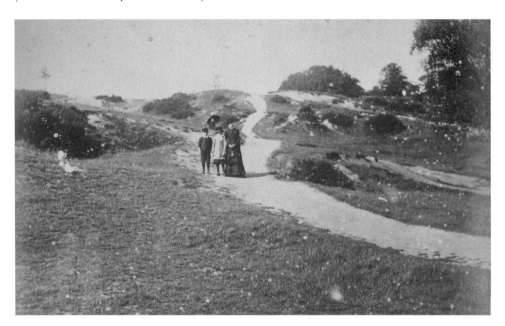

29. Path Over Heath, Leading to North End

Another view of the Heath still barely starting to recover from the massive sand extraction works of the 1860s locates this image somewhere in the Sandy Heath area, presumably towards the slopes leading down to North End. At first sight, any attempt to locate the position of Barratt's view would seem a futile endeavour. In fact, there is a location which fits both Barratt's generalised description and the topography of his photograph so well that I believe it can be tentatively identified; the spot is a short distance to the east of, and a few yards to the north of, the western end of Sandy Road, looking north-north-west towards the brow of the hillock that leads down not to North End, but to Wyldes Farm.

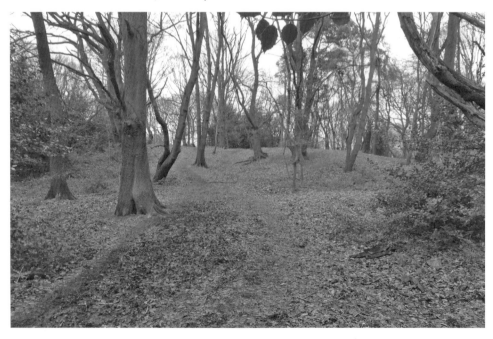

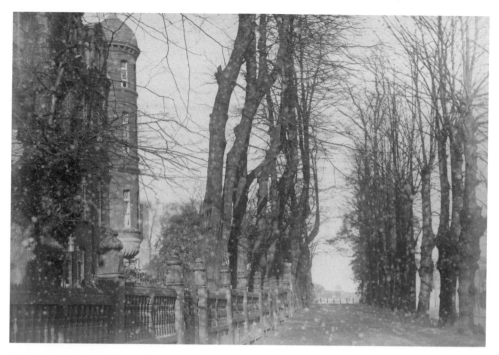

30. Well Walk (Foley Avenue)

The substantial red-brick terrace near the eastern end of Well Walk was built in 1882 in the grounds of Foley House, and was known until 1924 as Foley Avenue. The terrace, with its familiar domed turret, still stands, and Barratt's viewpoint can thus be easily identified, although the ornate wooden fence and the magnificent row of lime trees are both long gone. While Barratt's photograph must post-date 1882, the houses would nevertheless have only been a few years old at the time.

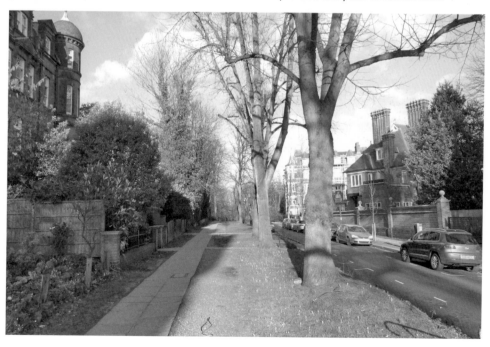

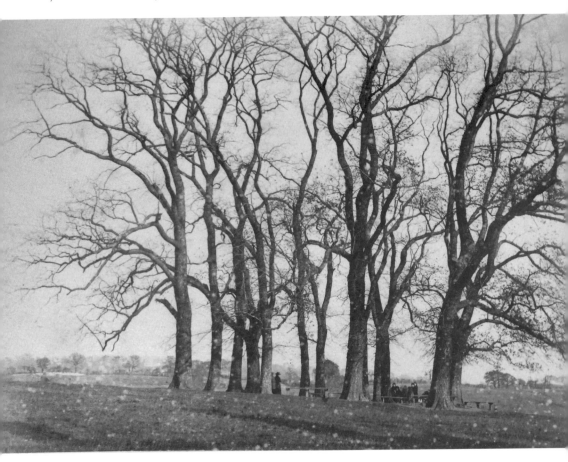

31. East Heath

The topography of this view does not appear to be of the far east of the Heath, which is much more undulating, and the tight, isolated clump of mature trees cannot be readily identified with any stands of trees existing today. Several clumps of trees are shown on the Ordnance Survey 25-inch map of 1915, in the flatter area between Parliament Hill and the Tumulus Field. Two such stands can still be seen there today, but they appear to be more recent plantings. However, a Raphael Tuck postcard from around 1930 shows what is certainly the identical clump, calling it 'The Thirteen Sisters'. The clump is described as being 'on the ridge of Hampstead', and gives no more clue as to where the location might be. For the present, then, this seemingly obvious view remains unidentified.

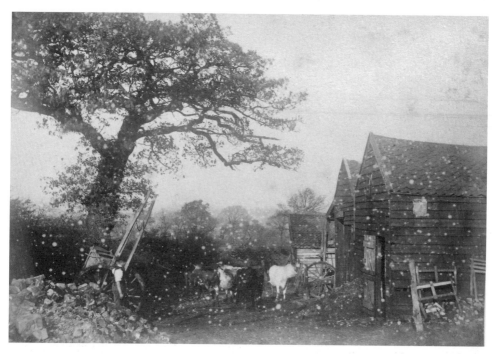

32. North End Farm

Also known as Tooley's Farm, this farm was located about 20 or 30 yards along the track that now leads from Wildwood Road northwards through the Heath Extension on land added to the Heath in 1907. No trace of the farm itself survives, but the ancient hedgerows of the Heath Extension today still delineate its fields, a rare survival of agricultural Middlesex. Photographs show that A. G. Tooley & Son were still operating the farm and delivering milk locally around 1910. This is another of Barratt's views published in Baines' 1890 *Records ... of Hampstead* (page 33), which dates it to no later than around 1889.

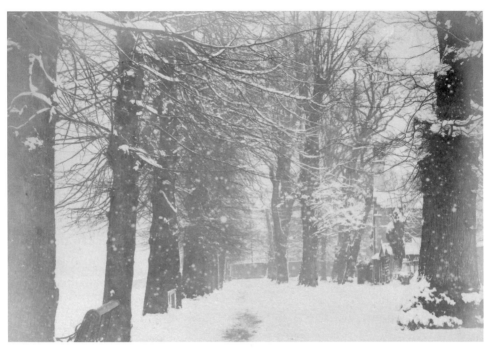

33. Judges Walk

The location of the camera in Barratt's view No. 9 was in the background from the two trees in the far left. This view looks north-east along Judge's Walk, in the opposite direction. As already noted, the fine row of lime trees on the left-hand side still survives, though those on the right are now gone.

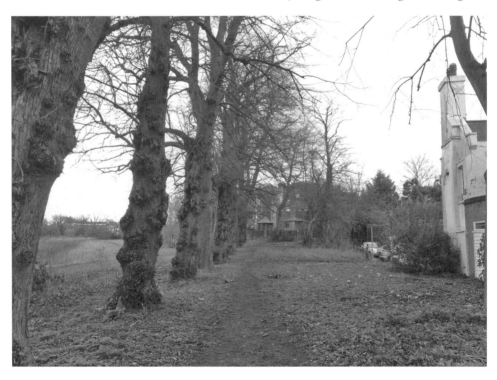

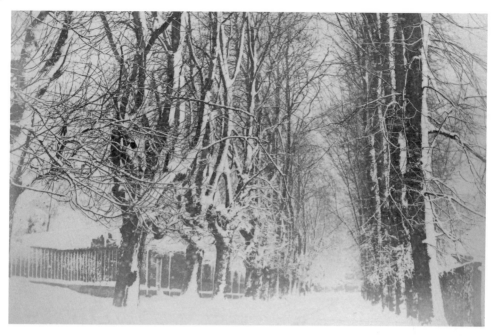

34. North End Avenue

This snowy scene is from the same position as Barratt's view No. 21, which was clearly taken in spring, as evidenced by the new leaves appearing on the trees. A few of the horse chestnuts on the left (west) side of the avenue, and limes on the right (east) side still survive today. The brick garden wall of the former Pitt House (*left*) is just visible between the trees in Barratt's view, although the return at far left appears to be some sort of paling fence and, in all, the scene today is no longer the popular formal avenue of late Victorian and Edwardian times, but a rustic track.

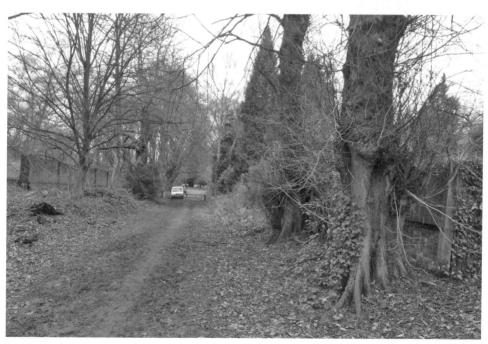

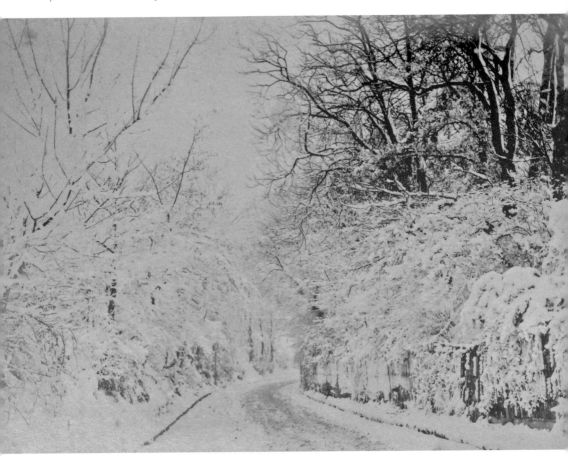

35. Road Leading to North End (*above*) & **36. Road Leading to North End (Lower End)** (*opposite*)
These appear to be essentially the same view, looking northwards along the deep cutting that now carries North End Way down to the Bull and Bush and North End, and divides the Pitt's Garden area of Sandy Heath from the eastern edge of West Heath. No. 36 is somewhat closer to the bend. Unfortunately, attempting to take the pictures today from Barratt's viewpoints would entail a somewhat higher personal risk from motorised traffic speeding around a blind bend than would have been encountered by a photographer in the horse-drawn days of the 1880s. It therefore seemed prudent to take the 'now' view from the elevated pathway on the west side of the cutting. Though a busy road today, it seems to be no wider now than in Barratt's day.

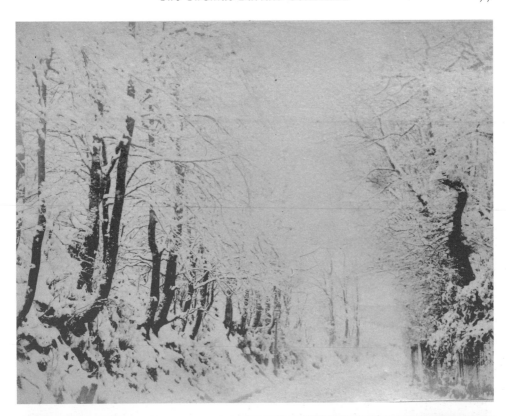

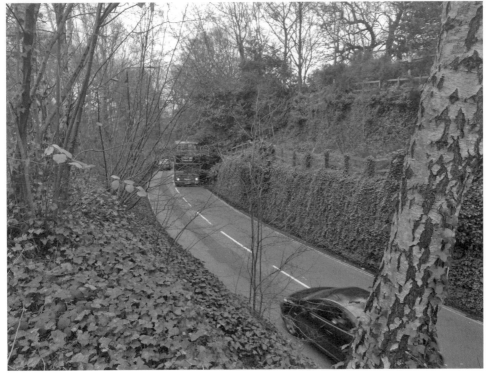

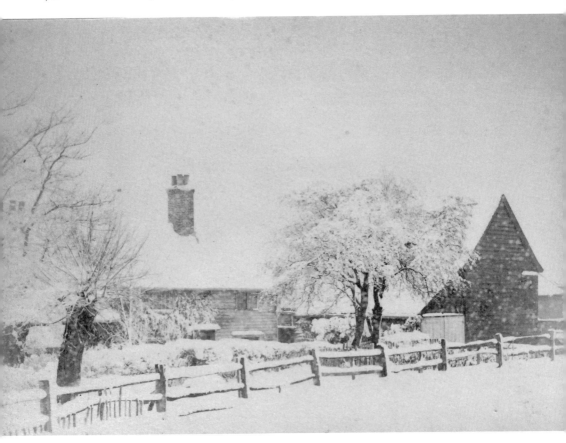

37. North End Farm – John Linnell Lived Here (Painter)

Barratt published several photographs of what is now known as Wyldes Farm in his *Annals*, but did not use either of the two views of the farm in this album. This famously picturesque farm, popular with artists and photographers since well before Barratt's time and continuing through to our own, is now partly concealed behind a low hedge (for understandable privacy reasons on such a busy part of the Heath). The 'now' view published here is from where Barratt placed his camera, but the buildings can be seen easily enough from various other publicly accessible viewpoints. The farm was also known as Collins Farm, after William Collins, another artist and acquaintance of Linnell (and father of novelist Wilkie Collins), and as Heath Farm. Linnell lodged there from 1824 to 1828.

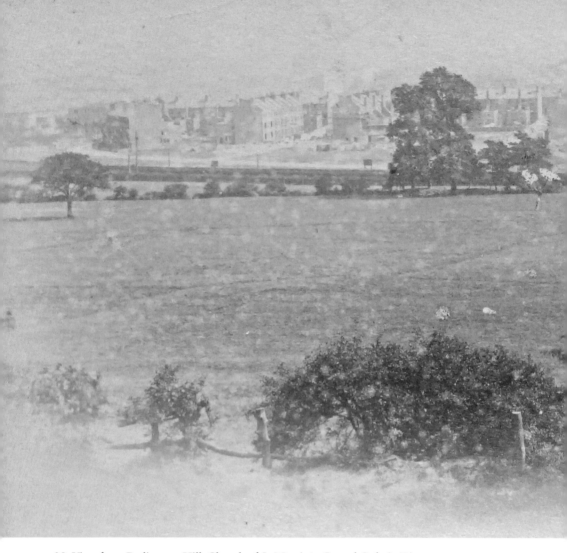

38. View from Parliament Hill, Church of St Martin's, Gospel Oak, in Distance

This, one of London's best-known vistas, looking approximately south from the top of Parliament or Kite Hill, was a noted viewpoint even in the 1880s. While all of London's now-prominent modern buildings and the sports field are of course absent, other changes over the intervening 120+ years are to some extent cosmetic. The tall – and, in Barratt's photograph, somewhat indistinct – spire of St Martin's church, Kentish Town, built in 1865, can be easily discerned today, though it has lost much of its spire, and the Hampstead railway still runs across the far side of the field. Beyond the railway, in Barratt's photograph, the estate between Savernake Road and Mansfield Road is just under construction, dating the photograph to around 1889/90, perhaps immediately after the land in the foreground had been added to the Heath. The most regrettable change in the view is the thoughtful placing of the Shard, London's tallest building at the time of writing, so that it completely destroys the world-renowned view of St Paul's Cathedral from Parliament Hill. This view was regarded as so important that it was, in theory, given protected status in the Greater London Plan as a strategic view within which no tall buildings would be allowed. Experience shows, however, that our heritage is only protected as long as it is not an inconvenience to 'progress'.

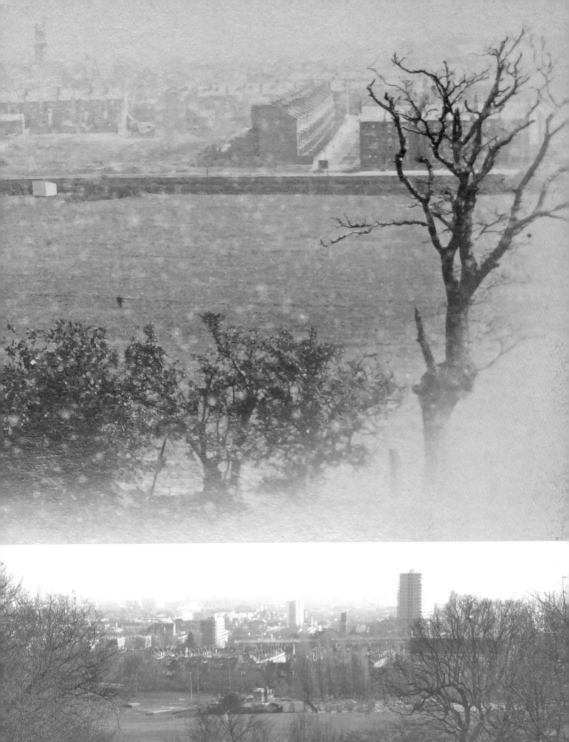
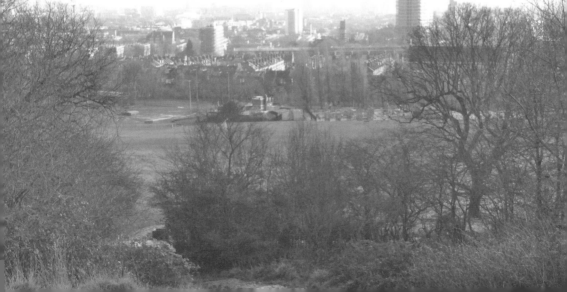

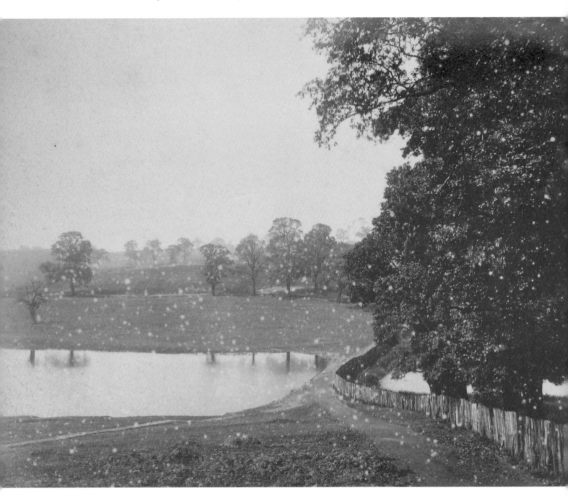

39. Highgate Pond

Barratt's view looks westwards across the causeway between what is today the bird sanctuary (right) and model boating ponds (left). The two tracks, the left leading from Merton Lane and the right leading down from the modern public toilets past the bird sanctuary, still exist. The large oak visible in the far right of the modern photograph may well be one of those in Barratt's view. The great difference is in the lack of mid-twentieth-century municipal planting of mainly willows, enabling the rolling agricultural fields of the 1907 Heath Extension acquisition to be seen, together with Parliament Hill in the distance of Barratt's view. The line of trees in the field beyond the pond marks an ancient hedgerow line, now entirely gone.

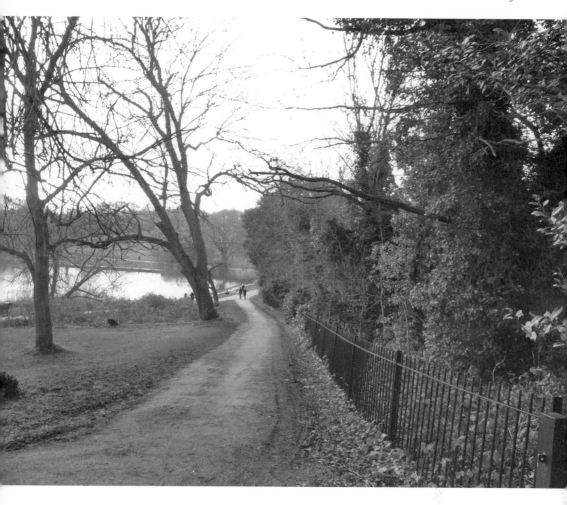

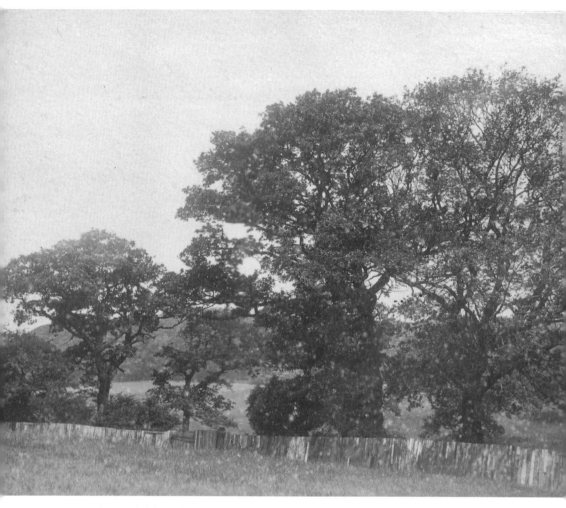

40. Lord Mansfield's Park, Highgate

Since the south-eastern sector of the Heath (Parliament Hill Fields) was acquired for the public in 1889, and most of the South Meadow ('Kenwood Fields') not until 1923, this and the following view are presumably of locations on the boundaries of the Kenwood estate proper, but still on the much larger area of land farmed by the Earl of Mansfield. While some knowledge of the Heath and its topography is an advantage, there is inevitably, in trying to identify views such as this, an element of informed guesswork, and the identifications of Views No. 40 and 41 can only be my 'best guess'.

This view, I suggest, looks north-west from point 40 on the Parliament Hill and Highgate map, with the camera located on what is today the Boundary Path (just out of view, to the left) on the southern edge of the South Meadow, which would at the time have been the southern boundary of the main Kenwood estate.

Today, the area has changed significantly. The grassy area in the foreground was taken over by scrub during post-war LCC management, sadly obscuring the magnificent ancient hedgerow and ditch represented by the line of trees behind the paling fence marking the bank and ditch, which can still be followed through the undergrowth now lining the top of the slope south of the South Meadow. The treeless area visible beyond the hedgerow in Barratt's view is what is now the South Meadow, which was virtually treeless until the 1950s, and was used during the First World War as a private golf course for the exiled Grand Duke Michael of Russia. The indistinct dark area beyond it is the outline of Kenwood.

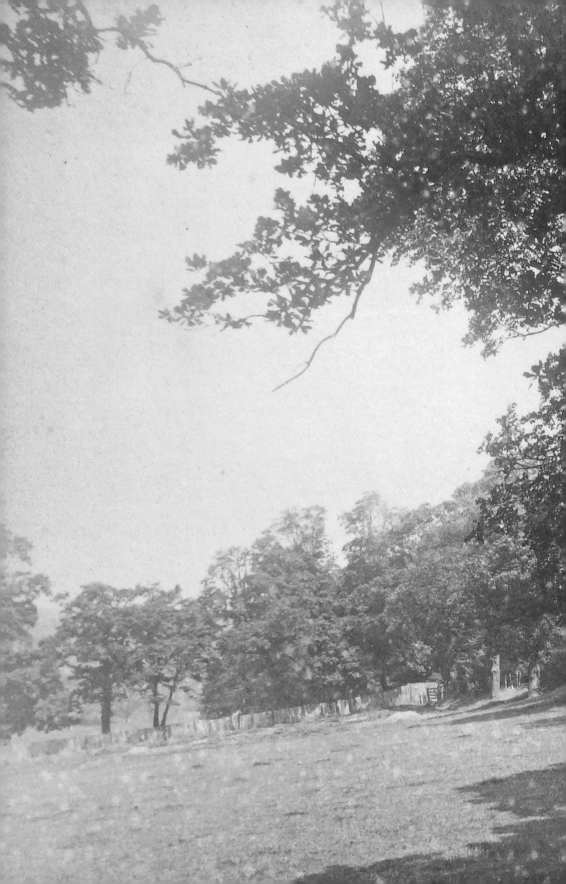

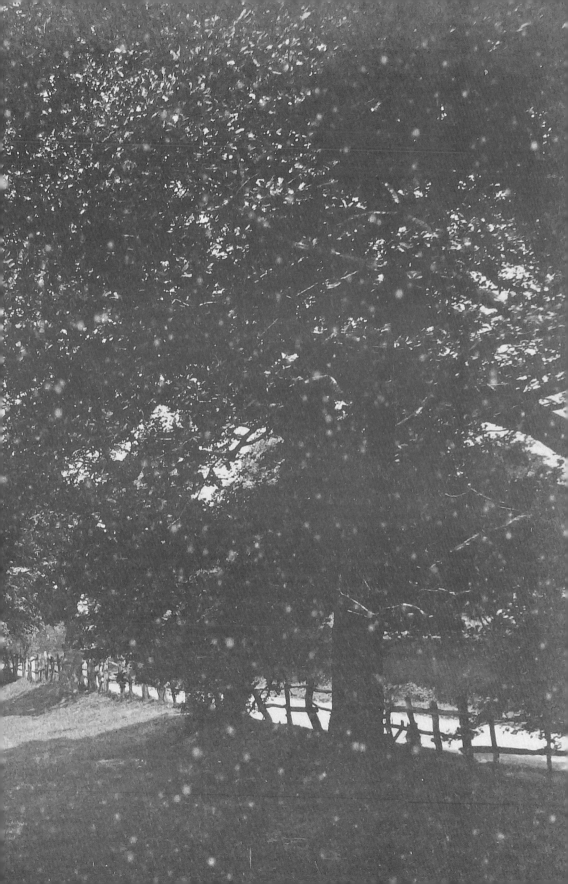

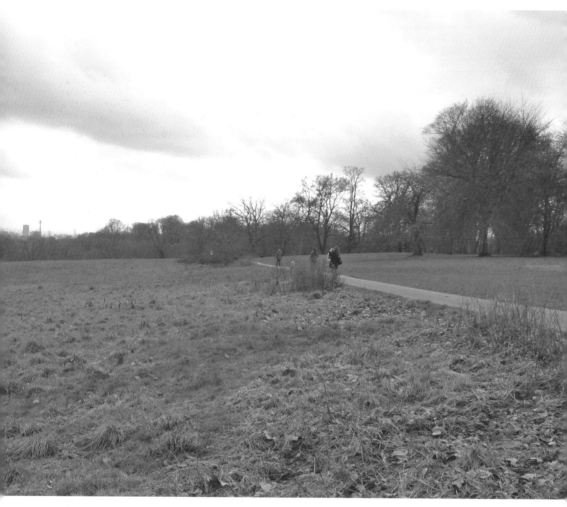

This page and previous: **41. Lord Mansfield's Park, Highgate**

One slope can look much like another. However, Barratt's identification limits the possibilities to somewhere on the boundary of the Kenwood estate and, with that in mind, the location that perhaps best fits the topography in Barratt's view would seem to be what is now the path running from the Kenwood stable block entrance to the Heath, down to Millfield Lane, which was part of the boundary of the estate. The line of trees, long lost, is marked on the 1894–96 Ordnance Survey 25-inch map, and the distant paling fence appears to curve round to the left as it follows what is probably the upper part of Millfield Lane as it descends the hill to the Highgate ponds chain. The modern path runs to the left of the line of trees, and the grassy slope is now the upper Cohen's field, part of the 1923 Heath acquisition land formerly belonging to Caen Wood Towers, now Athlone House. However, I would be delighted to hear from anyone who believes that they have a better suggestion.

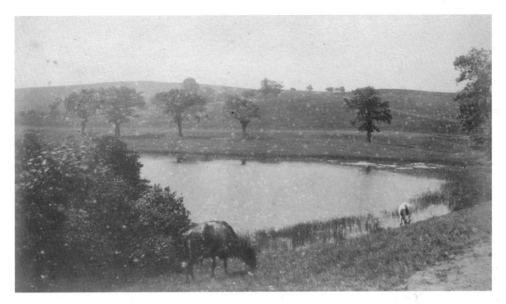

42. Highgate Pond

This shows the northern end of what is now the Highgate No. 1 Pond, with, in the far right, the causeway separating it from the Men's Bathing Pond. The grazing cattle show that it is still part of the farmland acquired for the Heath in 1889. The row of trees on the far side of the pond represents another ancient field hedgerow, now lost. The openness of Barratt's view – now obscured not only by many more trees but by a large poplar in the middle of the foreground – enables the undulating and hilly topography to be appreciated from this viewpoint somewhat more than is possible today.

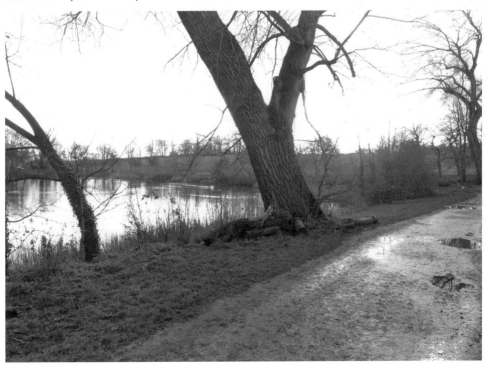

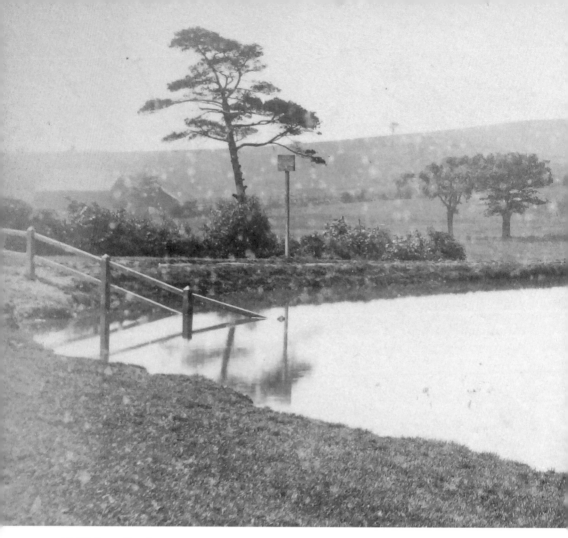

43. Highgate Pond

Barratt's view looks west across the southern end of what is now the Highgate No. 1 Pond, the grazing cattle again indicating that it is still farmland. The same row of trees in his view No. 42 can be seen here with, in the far left, what appears to be a Scots pine, a species now only to be found on the more sandy areas of the north-west Heath. His viewpoint, however, is today inaccessible on land owned by the 1890s flats of Brookfield Park. There is today an aluminium paling fence, seemingly at exactly the place where a wooden rail fence can be seen at the left of Barratt's view, indicating that the land on which the camera was placed was even then privately owned and not part of the lands farmed by the Earl of Mansfield. The modern photograph is therefore taken from immediately in front of that fence out of necessity, on top of the Highgate No. 1 Pond dam, on Heath land. Thanks to the relatively few trees, Heath visitors can still gain an appreciation of the hilly topography. The horizon appears to be much further off in Barratt's photograph, but the hedgerow following the modern pathway up to Parliament (Kite) Hill can be seen in the distance in both views.

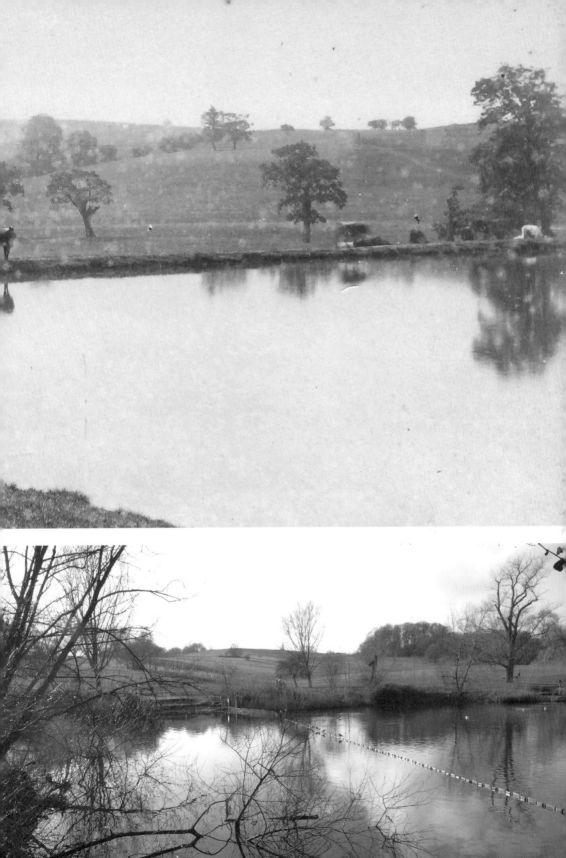

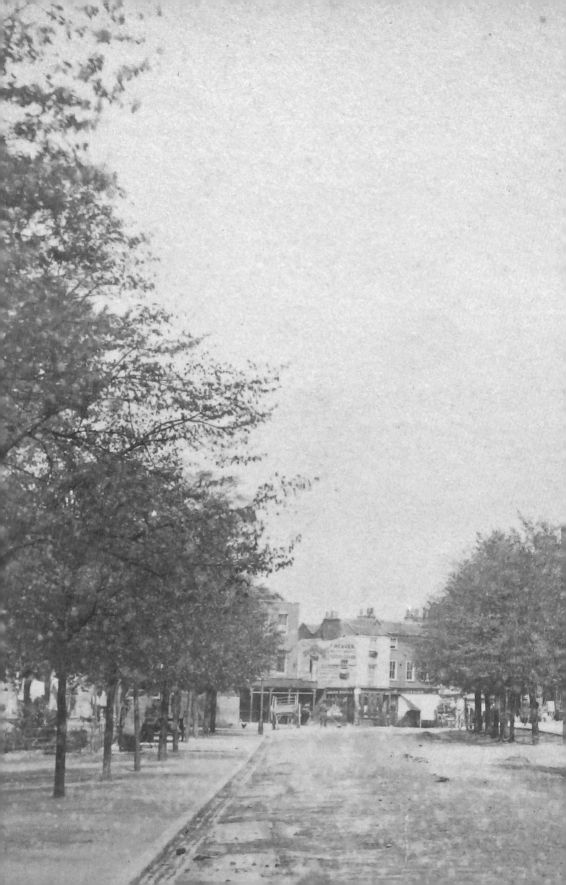

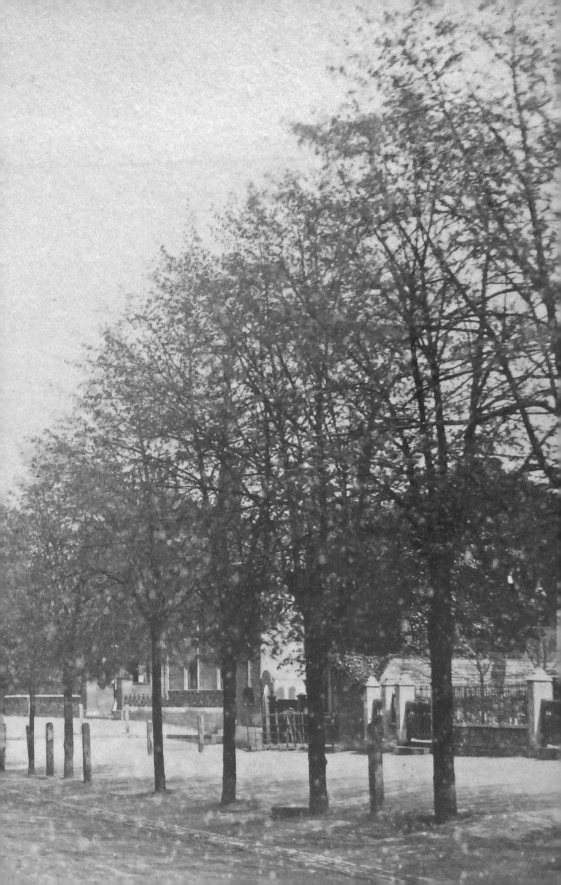

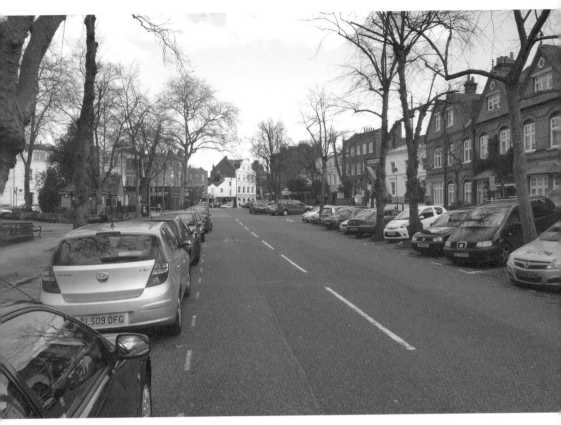

This page and previous: **44. Entrance to Highgate Town**

Barratt's only photograph of Highgate in the album was taken in the roadway of South Grove, near the south-western corner of Pond Square, looking towards Highgate High Street. In the distance can be seen the wooden canopy of the butcher's shop at No. 62 (surviving today only as a replica, the original having been demolished by a bus in the 1980s), and immediately to its right is the weatherboarded corn chandler's building at No. 60, still there today and a unique survival of London's agricultural past. Above it, under high magnification, can be seen the name of Frederick Weaver, tobacconist, who occupied No. 60 Highgate High Street from 1884 to 1894, thus giving a date bracket for this photograph.

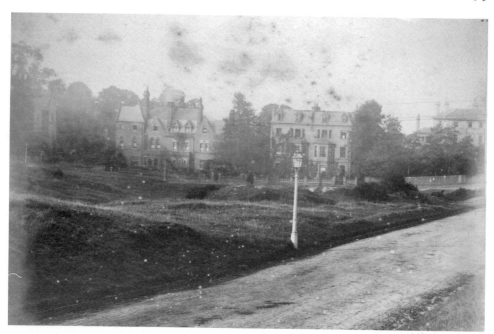

45. Untitled

This untitled view is easily identified as looking south-west across the upper (south-western) end of West Heath Road, on its northern side, across Judges Hollow (an enormous early sandpit, painted by Constable) to the still-surviving 1860s–70s houses of Branch Hill. The 1980s Firecrest flats can be seen at the far end of the road in the 'now' photograph.

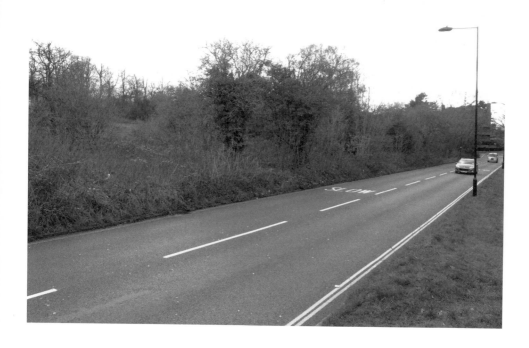

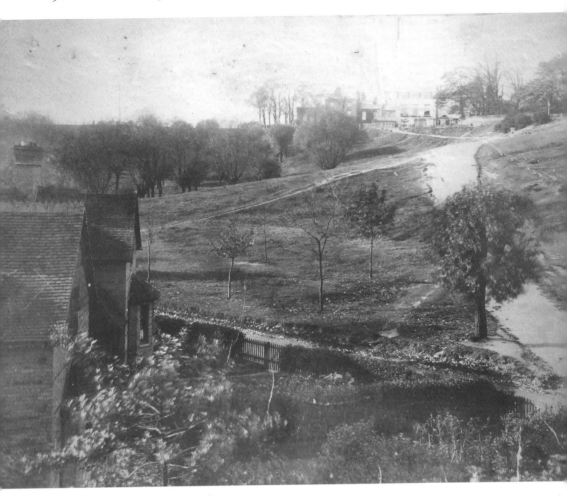

46. Untitled

This view, also untitled, looks approximately west from the Vale of Health area towards the old Jack Straw's Castle (badly damaged during the Secord World War and rebuilt in its present form in 1962) with, on its left, the Old Court House and, on its right, some of the houses also destroyed during the war and their land incorporated into Hampstead Heath. It also shows the wide track still accommodating the upper fairground on bank holidays, leading from the western end of Spaniards Road down to the Battery past the famous row of Fulham oaks just out of Barratt's picture to the right. It should thus be a simple matter to locate Barratt's viewpoint. However, today's dense growth of trees on the slopes, which were virtually treeless in Barratt's time, completely obscures both the buildings and the topography. The buildings in the left foreground of Barratt's view no longer exist, and the *c.* 1890 terrace of houses visible in the 'now' photograph had not been built at the time of Barratt's view. The general location is not in doubt, but, because of the changes, the exact location can only be a best guess; it looks across the extreme northern tip of the Vale of Health settlement, across Hatchett's Bottom, from a position on the slope immediately to the east of the track leading from the Battery to the Vale of Health Pond, with the buildings in Barratt's left foreground on what is now the northern edge of the vacant fairground site.

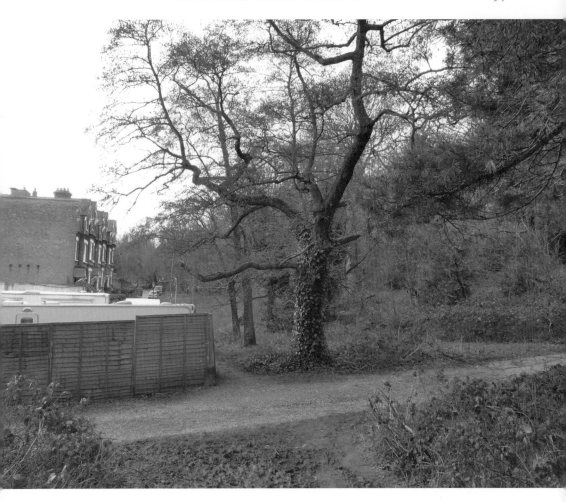

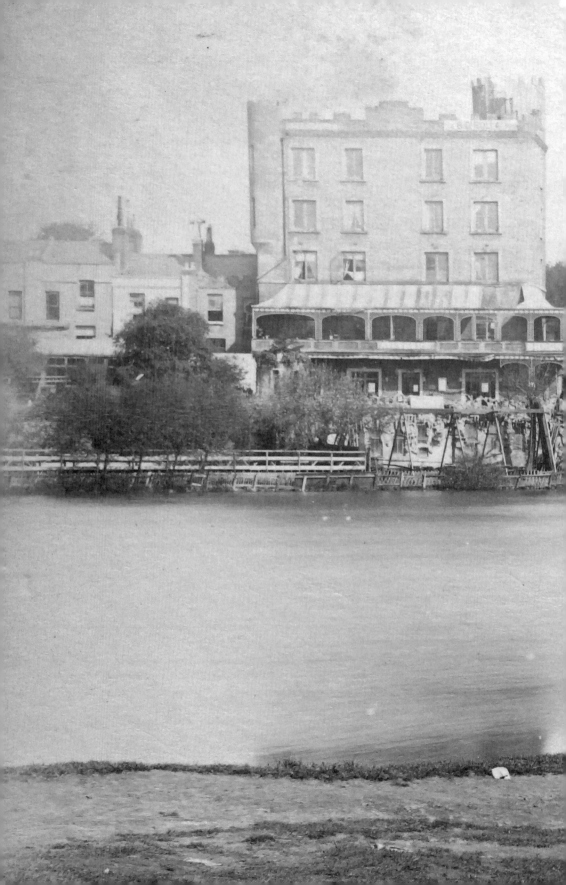

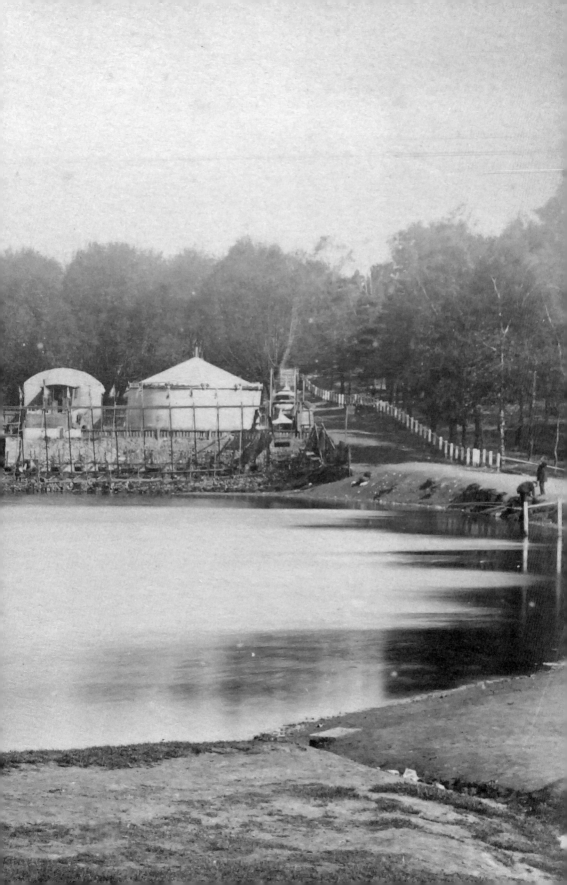

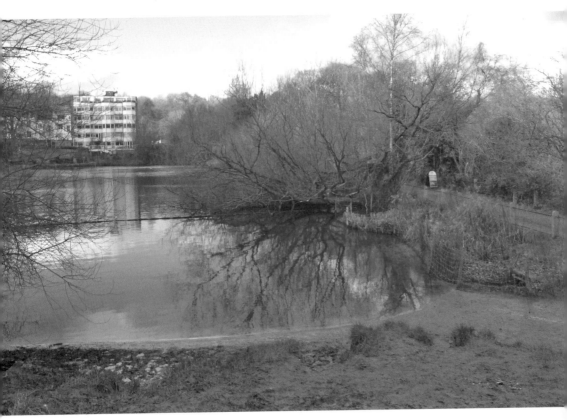

This page and previous: **47. Vale of Health Pond**
Barratt's view was taken from the slope immediately above the south-eastern tip of the pond.
It shows a scene at once familiar and yet much changed in detail in terms of both buildings and
vegetation. The most prominent building in his view is the 1863 Vale of Health Hotel, with the
swings and other structures of the lower fairground visible to the right. Under magnification,
to the right of the pond, the time-honoured pursuit of fishing, popular in the 1880s, can be seen.
The hotel building was demolished in 1964 and replaced with the block of flats seen in the 'now'
view, named after the artist Stanley Spencer.

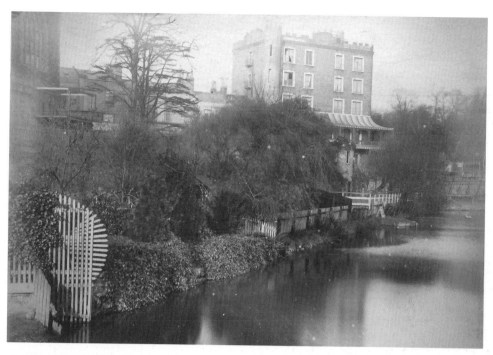

48. Vale of Health Pond

Barratt's view looks approximately north-east along the western bank of the pond, from close to its south-western corner. The land visible in his photograph was and remains privately owned and inaccessible. The trees and undergrowth present today on the Heath allow access to Barratt's viewpoint only with difficulty, and were the 'now' view to be taken from that spot, the scene would be almost totally obscured by vegetation; the modern image was therefore taken some yards to the right of Barratt's viewpoint, but shows essentially the same scene.

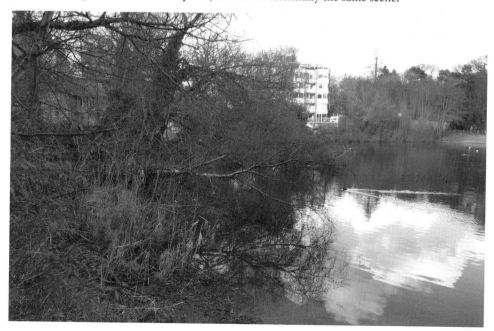

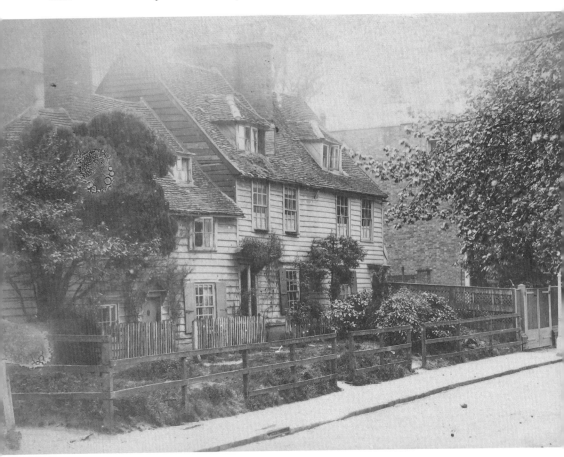

49. Rustic Cottages Near Bull and Bush

Although these picturesque weatherboarded cottages, formerly on North End near the junction with the Avenue, were popular with photographers, there is little information on them other than a suggestion that they may be late seventeenth or early eighteenth century. Sadly, they were destroyed by a parachute mine during the Second World War. This view looks west along North End towards North End Road, with the junction of the Avenue just visible in the left foreground.

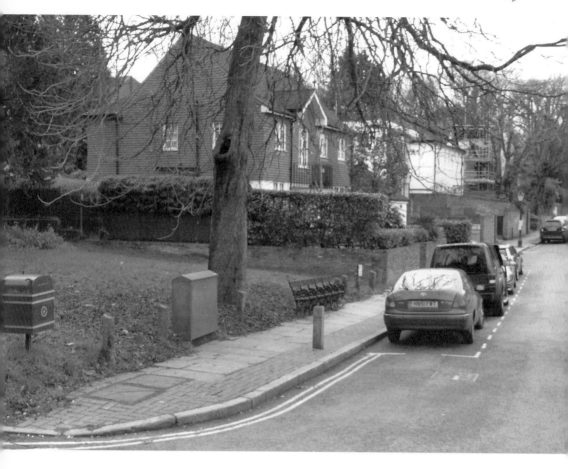

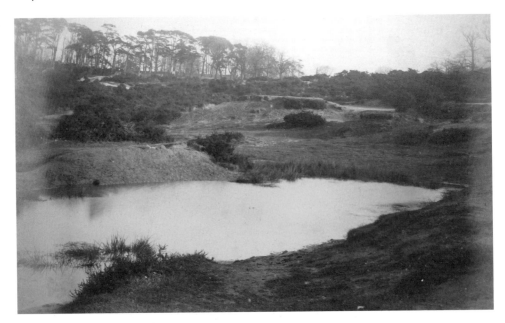

50. Untitled View Across Sandy Heath

Though Barratt gives no location for this, it almost certainly shows one of the ponds on Sandy Heath that appeared after the extensive sand digging of the 1860s. The topography has, in all likelihood, been affected by natural and human erosion and wartime sand digging since the 1880s, when Barratt would have taken the photograph, and the sparse gorse scrub has now been replaced by dense trees with relatively little undergrowth. However, since no pond is visible to the right (the south) in Barratt's view, in all likelihood it looks across what is now the southernmost of the three main ponds on the Sandy Heath. Unlike the other two, this pond is now little more than a marsh. What enables the view to be identified with some confidence is the row of pines on the horizon, almost certainly the still-extant 'Constable's Firs' on the far side of Spaniards Road, the ridge of which runs across the background.

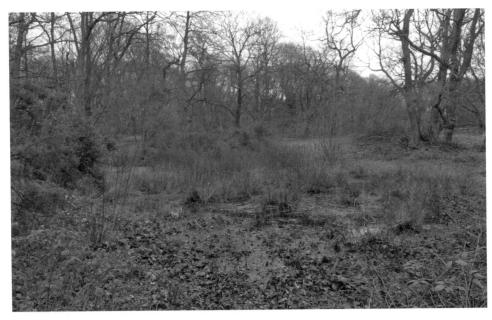

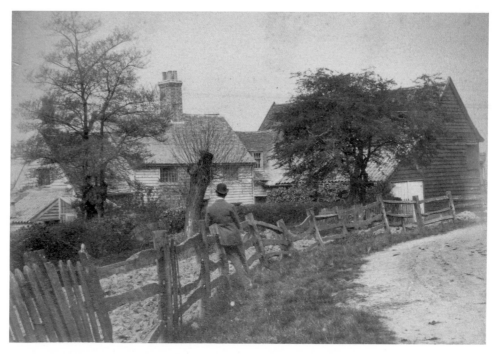

51. North End (or Collins) Farm

This view is very close to the location of No. 37 and shows almost the same view of Wyldes Farm. Judging by the leaves just sprouting on the trees, it was taken in early spring. The view today, from the position of Barratt's camera, is somewhat obscured by an evergreen hedge. However, as with view No. 37, an excellent view of this historic complex of seventeenth- to early-nineteenth-century buildings, a rare survival of agricultural Middlesex, can be obtained from the public realm, without intruding on the owners' privacy, by walking along the track a short distance.

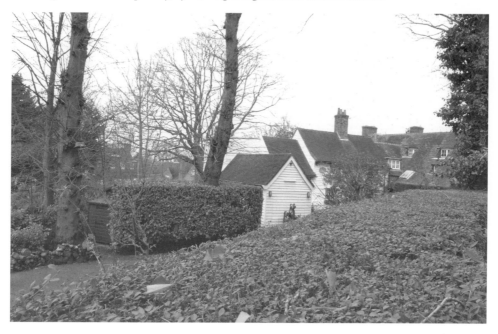

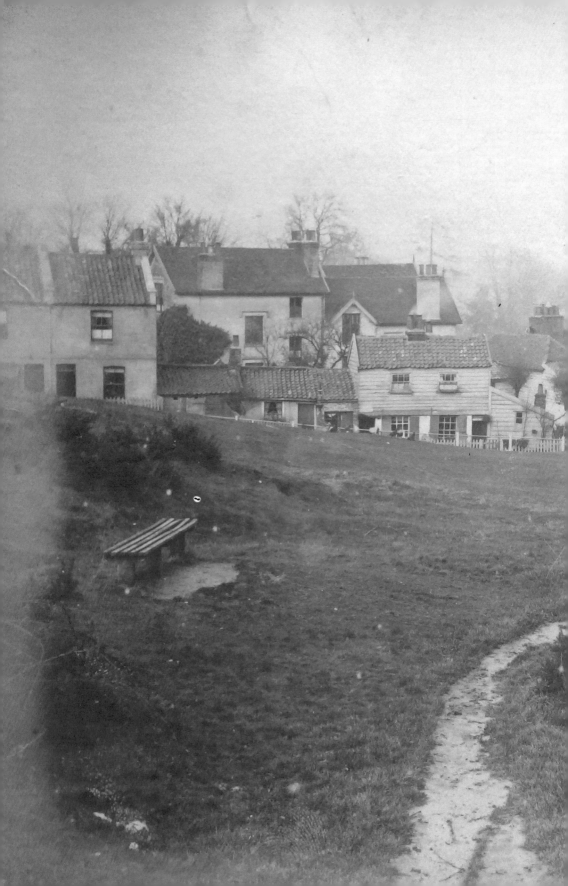

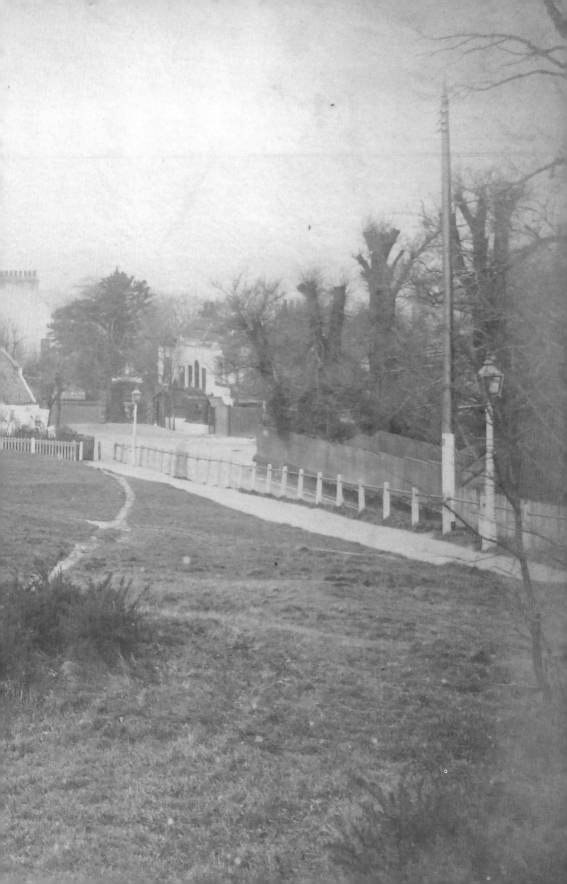

This page and previous: **52. North End and Bull & Bush**

The location of this view can be identified easily enough, looking north towards the hamlet of North End on the west side of North End Road, with the Bull and Bush pub in the distance towards the right, some years before popular singer and entertainer Florrie Forde made it world-famous in 1903 (for a nostalgic break, try https://archive.org/details/FlorrieForde-01-10). However, Barratt's viewpoint is now an impenetrable thicket of bramble, saplings and trees, and the closest I was able to get to take the modern view was about 25 yards north (downhill) from where he placed his camera. The North End cottages can be discerned, but the Bull and Bush is now partly obscured by trees in winter and, in summer, would be completely so.

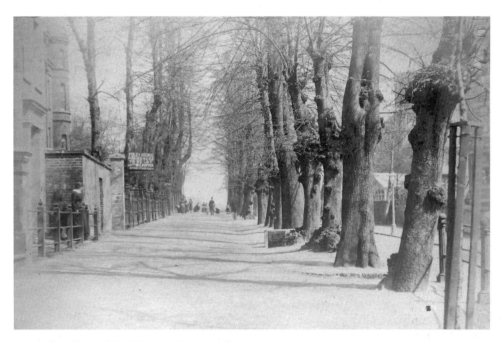

53. Well Walk Looking Towards East Heath

This view, taken some 30 yards to the west of view No. 30, looks in the same direction, along the north side of Well Walk towards West Heath Road, with the turret of the newly built Foley Avenue visible at left. The single-storey brick annexe to the house in the left foreground remains today as a reference point. The lime tree opposite it in the 'now' view may be a survivor of the fine avenue probably planted during the eighteenth-century heyday of Well Walk as a fashionable spa.

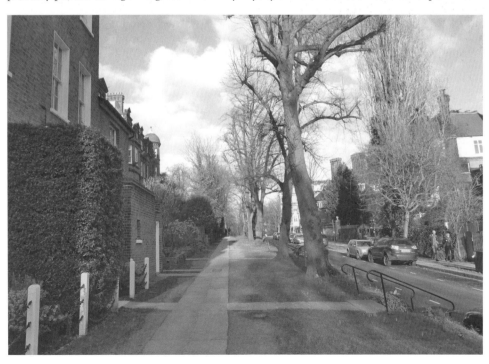

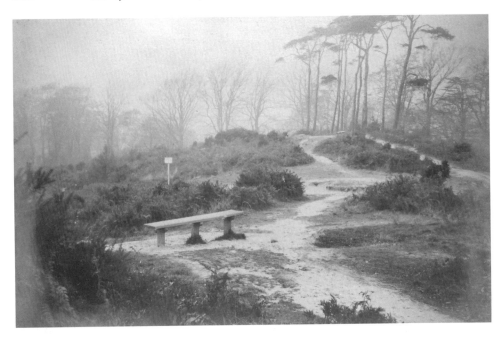

54. North End Firs

The vegetation of the area has changed to such an extent that it is difficult to be certain about Barratt's exact viewpoint. However, the relative positions of the 'firs' in Barratt's photographs (Nos 8 and 54) indicate that his pictures were taken from approximately the same angle, and the topography appears to favour a position approximately level with, but some yards further back (west) from, view No. 8. The topography, again, is not natural, but the result of extensive sand digging during the eighteenth and nineteenth centuries.

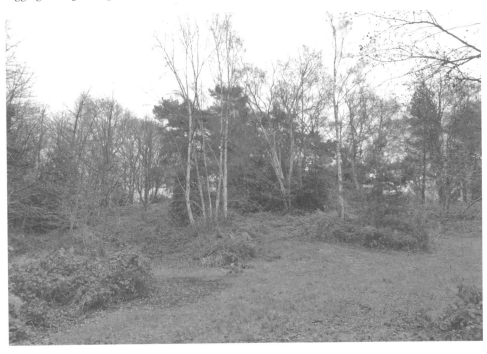

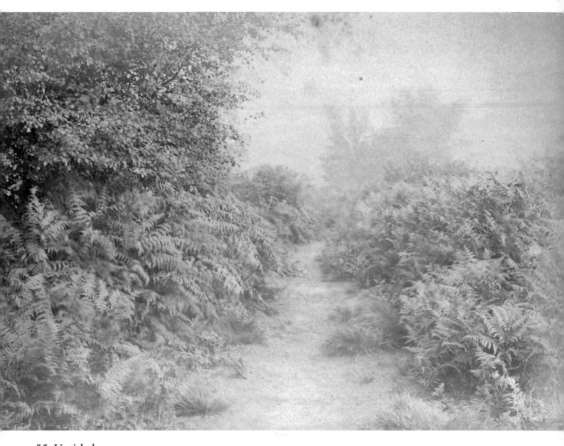

55. Untitled
Barratt's view is untitled, and the location of this rustic track cannot be identified.

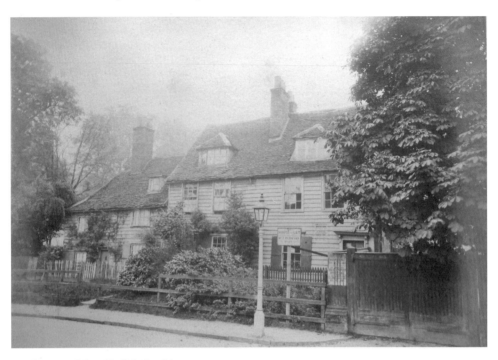

56. Cottages Near 'Bull & Bush'

These are the same cottages in view No. 49, looking east along North End. The sign outside the cottage bears the name of T. Clowser, a prominent local builder. Directories show him as being in business by 1850, and employing forty men by 1851. His address in 1885 was No. 27 Hampstead High Street. Thomas Clowser was born in Hampstead in 1827 and died on 20 July 1889, thus giving a useful *terminus ante quem* for the photograph.

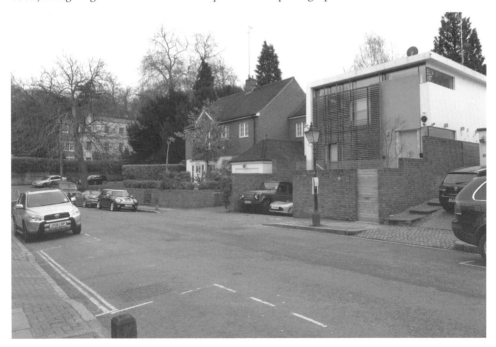

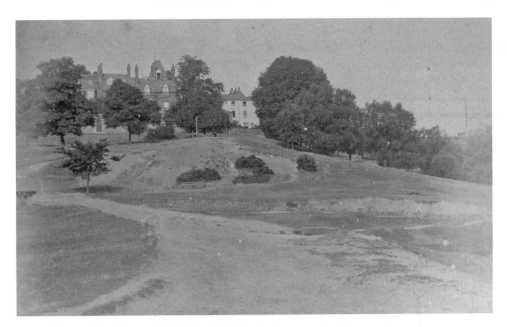

57. The Back of 'Bellmoor' & 'The Lawn'

Bellmoor, the imposing red-brick house at the top of the slope fronting on to the top of East Heath Road, was Thomas Barratt's home from 1877 to 1914. Barratt converted four early-nineteenth-century cottages into one house, using the name of one of them to give the building its name. The photograph on page 121 of Wade (1989), showing the Moorish Room in Bellmoor, indicates that the interior must have been quite spectacular. The house was demolished and replaced in 1929 by the present neo-Tudor flats of the same name. 'The Lawn', now Whitestone House, was a Regency house, enlarged in 1934 by Clough Williams Ellis, who in 1929 lived in Romney's House, Holly Hill. Rather modestly photographing his own house from below and the rear, Barratt's view was taken from the extreme south-eastern tip of the built-up area of the Vale of Health, and the location can be easily found today.

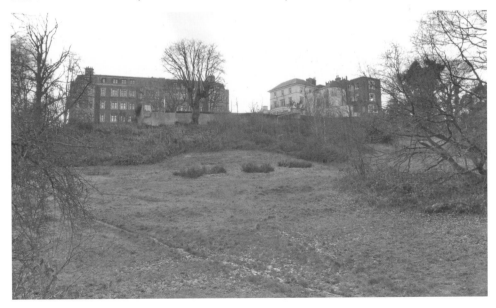

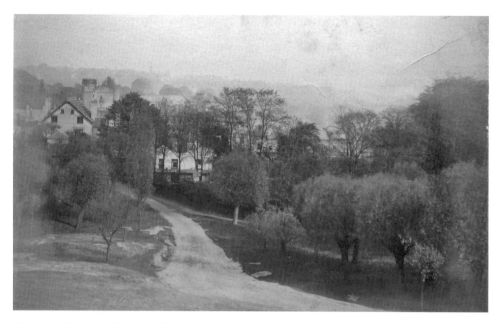

58. Vale of Health. Highgate Church in Distance

Several tracks and paths lead down to the Vale of Health, and identifying this view was a matter of trial and error. Fortunately, the distinctive ridged-roof white house at left, with two small and two larger upper-storey windows, still exists, just visible between the trees at left-centre, and identifies the viewpoint as about halfway down the Vale of Health road leading from East Heath Road to the Vale. Interestingly, the *c.* 1880s villas now marking the entrance to the settlement on the right-hand side of the road are not present in Barratt's view, dating it to no later than the mid-1880s.

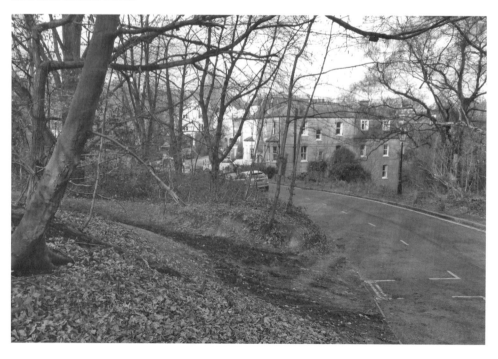

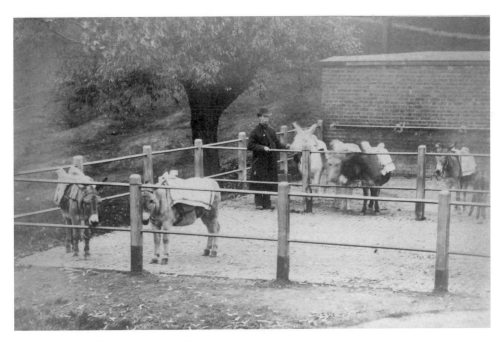

59. Donkey Stand Near 'the Pound'

The donkey rides were a popular feature of the Whitestone Pond area from the mid-nineteenth century until well into the post-war era, but the original stand where they were kept, until at least the early years of the twentieth century, was an enclosure of hard-standing abutting the north side of the eighteenth-century brick-built Cattle Pound. This now-listed structure is today one of the Heath's historic monuments, just below the Whitestone Pond above the Vale of Health, though obscured by vegetation. The area of the donkey stand is now completely overgrown.

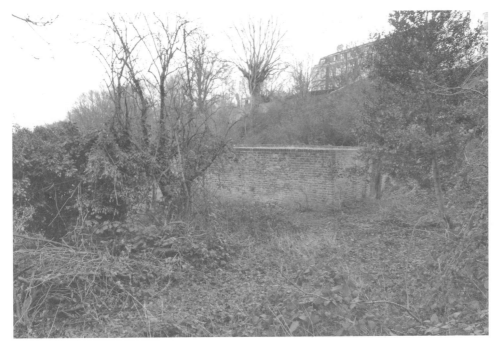

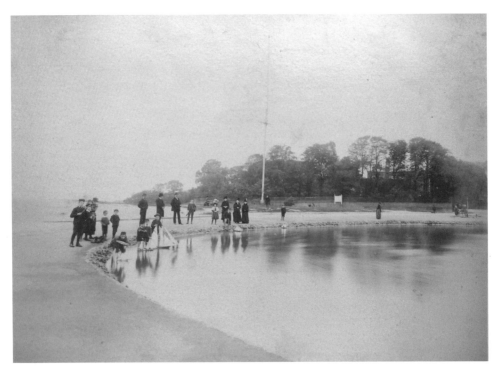

60. Whitestone Pond by Jack Straw's Castle

The location of Barratt's view can easily be found at the southern edge of Whitestone Pond near the junction of West Heath Road and Heath Street, and the scene is little changed, other than the harder edge to the pond, the spread of trees across the western skyline, and the more recent (and welcome) softer landscaping of the area.

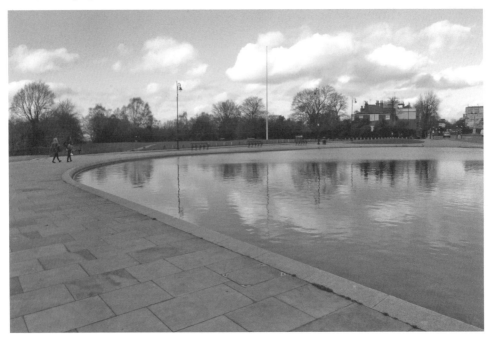

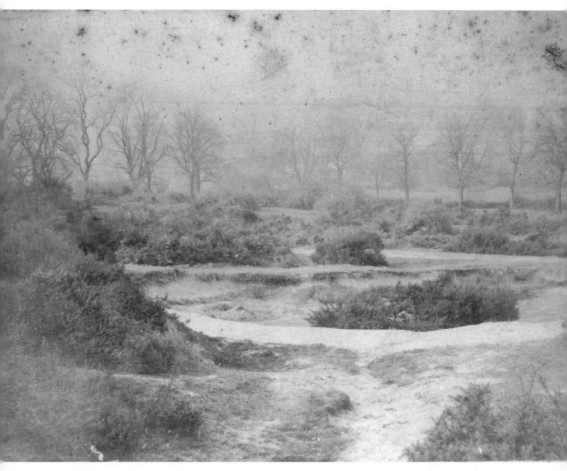

61. Unidentified View

Barratt gave this view – taken in winter, from the absence of leaves on the trees – no title, so its location is only guesswork. However, there are some clues. The foreground to middle distance, which slopes gently down from the camera, appears to be one of the areas heavily disturbed during the mid-nineteenth century by sand digging, and consists of bare ground with a few sparse gorse shrubs. Two lines of trees appear to be in the distance, following a hedgerow and converging on each other at roughly a right angle, with the line of trees at left at a somewhat more oblique angle to the camera than that at the right. In the far distance, on the right, appears to be an open field, and close study indicates more trees beyond it on land sloping gently upwards again. The scene is of an area of fairly flat terrain with gently sloping fringes, heavily disturbed by sand digging and adjacent to what was then still farmland.

The present Sandy Heath, between Spaniards Road and North End Road, was the area most affected by sand digging, being reduced to a lunar-like landscape in the 1860s by Sir Thomas Maryon Wilson in his efforts to destroy the Heath and render it suitable for development. This is most dramatically shown in the photograph on pages 95–96 of Alan Farmer's *Hampstead Heath* (1984 edition). A clear junction of heathland and grassy farmland can be seen on London Sheet 18 of the 1894–96 25-inch Ordnance Survey Map, on a line running from North End to Spaniards Inn, and this line can still be followed today. Part of the farmland became what is now the Heath Extension, with Hampstead Garden Suburb built around it to the west, north and east from the early 1900s onward.

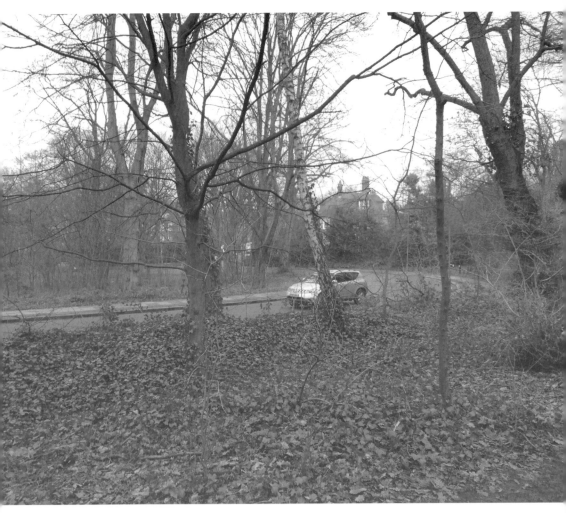

My suspicion is that this view was taken looking approximately north, from the northern slopes of the Sandy Heath, to the fields of what was then Wildwood Farm, now the Heath Extension, at the point where it meets the southern end of Wildwood Road. Close study of Barratt's view shows no visible buildings, yet the 1894–96 map shows that the heath/farmland boundary was, by the time of his photograph, the location of a number of buildings. The new houses were at Heath Farm, North End, immediately to the east of North End (the site now also within the Heath Extension), and Wildwood Farm. There were also buildings behind the Spaniards firs, at what is now known as Spaniards End.

The only gap along this line that would have enabled Barratt to take the view without showing any buildings is between Wildwood Farm and Spaniards End, and the topography is only flat enough to match the view in the area immediately to the east of Wildwood Farm. This would suggest that the camera was located near the bottom of the slope from Sandy Heath, looking across what is today Ikin's Corner, on Wildwood Road, towards Turner's Wood (today in private ownership but in good condition, an almost miraculous urban survival of ancient woodland). Indeed, the trees vaguely discernible in the background may be Turner's Wood. Any better suggestions for the view's location would be welcome. Barratt's viewpoint is probably slightly higher up the slope from, and slightly to the right of, the modern photograph, but that area is now so densely covered with vegetation that the view would show little else but trees.

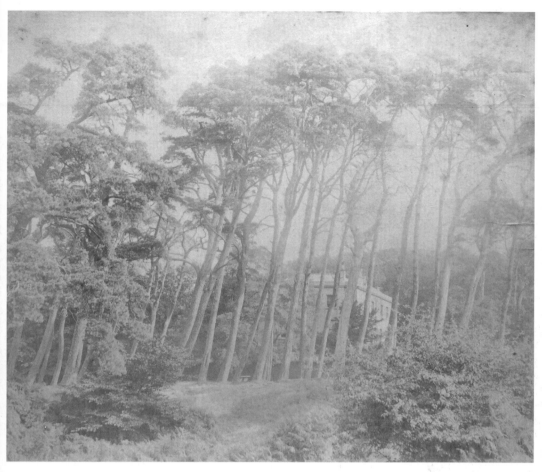

62. The 'Firs' by the Spaniards
This is effectively the same scene as in Barratt's photograph No. 23, and appears to have been taken only a few yards to the left (south) of it. It is another of Barratt's views published in Baines' 1890 *Records ... of Hampstead* (page 109), dating it to no later than around 1889.

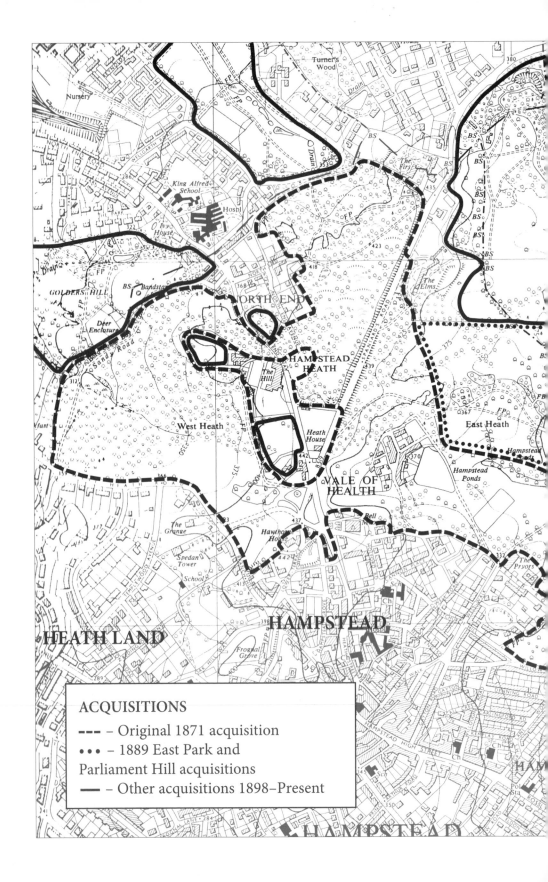

HEATH LAND

HAMPSTEAD

ACQUISITIONS

- - - – Original 1871 acquisition
• • • – 1889 East Park and
Parliament Hill acquisitions
—— – Other acquisitions 1898–Present

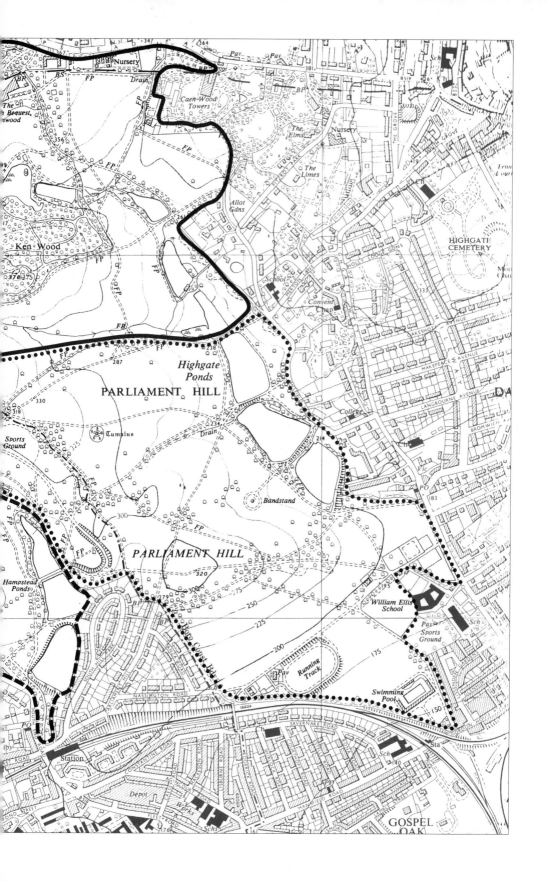

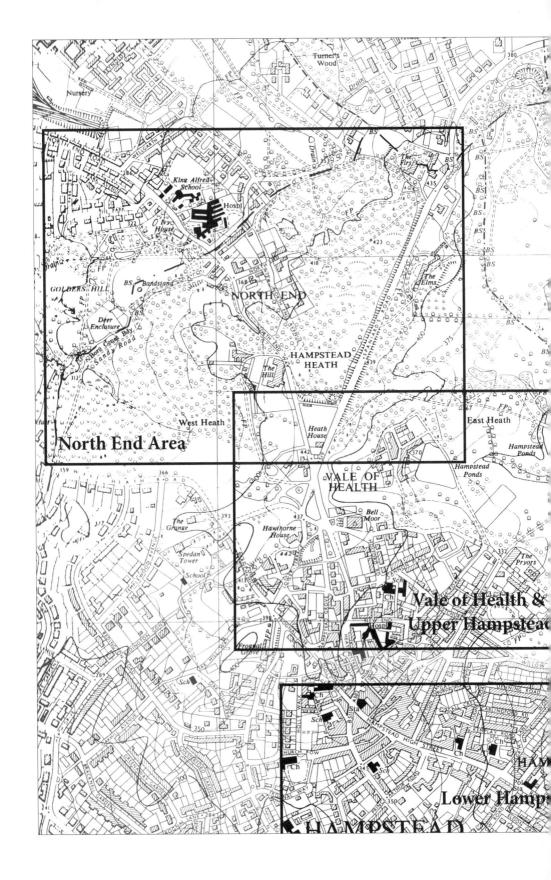

North End Area

**Vale of Health &
Upper Hampstead**

Lower Hamps

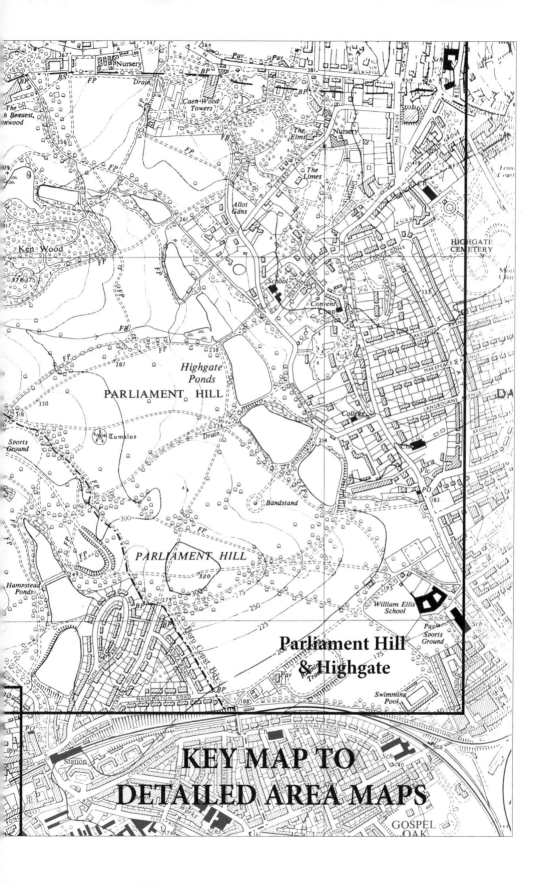

KEY MAP TO
DETAILED AREA MAPS

Parliament Hill
& Highgate

DETAILED AREA MAPS

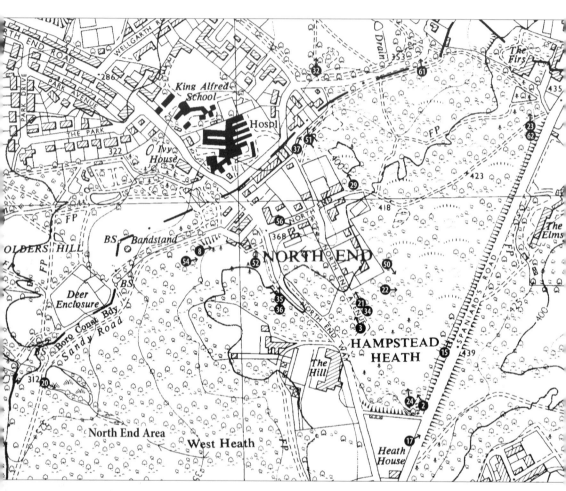

North End Area.

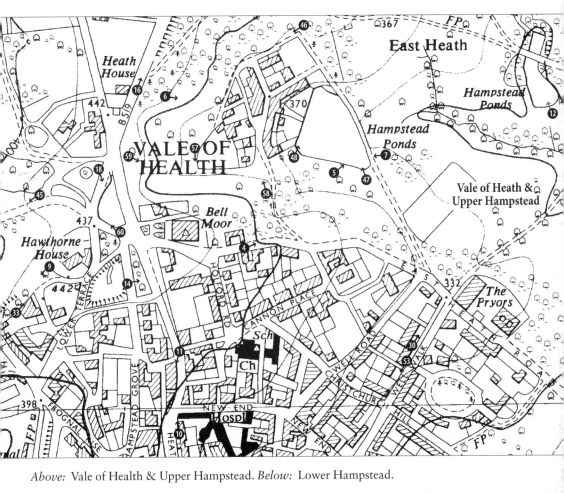

Above: Vale of Health & Upper Hampstead. *Below:* Lower Hampstead.

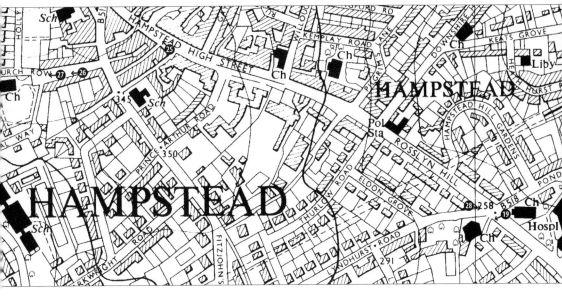

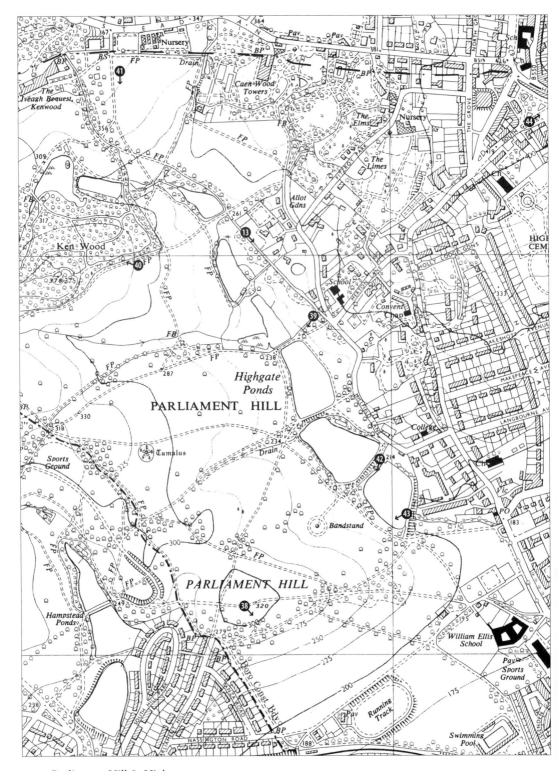

Parliament Hill & Highgate.

Short Bibliography

Baines, F. E., *Records of the Manor, Parish and Borough of Hampstead, to December 31st, 1889* (London, 1890).

Barratt, Thomas, *The Annals of Hampstead* (3 vols, London, 1912; repr. 1972 by Lionel Leventhal Ltd., 2–6 Hampstead High Street, in association with the Camden Historical Society).

Farmer, Alan, *Hampstead Heath* (New Barnet: Historical Publications, 1984).

Ikin, Christopher W., *Hampstead Heath: How the Heath was Saved for the Public* (Greater London Council, 1971, 1972, 1978).

Jenkins, Simon and Jonathan Ditchburn, *Images of Hampstead* (Richmond-on-Thames, 1982).

McDowall, David and Deborah Wolton, *Hampstead Heath: The Walker's Guide* (Richmond, Surrey, 1998).

Richardson, John, *Hampstead One Thousand* (New Barnet: Historical Publications, 1985).

Wade, Christopher, *Hampstead Past* (New Barnet: Historical Publications, 1989).

Wade, Christopher, *The Streets of Hampstead* (Camden History Society 1972; 2nd edn. 1984).

White, Caroline, *Sweet Hampstead and its Associations* (London, 1903).

MICHAEL HAMMERSON

HIGHGATE
From Old Photographs

Highgate From Old Photographs

Michael Hammerson

Join Michael Hammerson in exploring the past life of this historic
village and some of its colourful residents through old photographs,
many of which are previously unpublished.

978 1 4456 1838 8

128 pages

Available from all good bookshops or order direct
from our website www.amberleybooks.com